VANDERBILT FOOTBALL

VANDERBILT FOOTBALL
TALES OF COMMODORE GRIDIRON HISTORY

BILL TRAUGHBER

Published by The History Press
Charleston, SC 29403
www.historypress.net

Copyright © 2011 by Bill Traughber
All rights reserved

First published 2011

ISBN 978-1-5402-0641-1

Traughber, William L.
Vanderbilt football : tales of Commodore gridiron history / Bill Traughber.
p. cm.
ISBN 978-1-60949-423-0
1. Vanderbilt University--Football--History. 2. Vanderbilt Commodores (Football team)--History. I. Title.
GV958.V3T73 2011
796.332'630976855--dc23
2011028516

Notice: The information in this book is true and complete to the best of our knowledge. It is offered without guarantee on the part of the author or The History Press. The author and The History Press disclaim all liability in connection with the use of this book.

All rights reserved. No part of this book may be reproduced or transmitted in any form whatsoever without prior written permission from the publisher except in the case of brief quotations embodied in critical articles and reviews.

To my friend Carlton Flatt, the best football man I know and who was my coach at Brentwood Academy.

CONTENTS

Foreword, by Rod Williamson	9
Preface	11
Vanderbilt Football Began with a Challenge	15
Sewanee Was Vanderbilt's First Rival	22
Nashville Game Ends with 1896 Riot	27
Dan McGugin Became a Coaching Legend	31
Famous Carlisle Indians Play Vanderbilt	36
Vanderbilt Ties Powerful Yale in 1910	41
Ray Morrison, a Player and Coach	46
Ty Cobb Practices as Vanderbilt Football Player	51
Vanderbilt Smashes Bethel 105–0	55
The Commodores' 1915 Point-a-Minute Team	58
Irby "Rabbit" Curry Inspired Vanderbilt	62
The Vanderbilt and Vols Conflict of 1918	66
Josh Cody, a Tough Two-Way Player	69
Dudley Field Is Dedicated in 1922	75
Commodores Win First Northern Game in 1924	81
Lynn Bomar Was a College Hall of Famer	85
The Legend of Dixie Roberts	90

Contents

Fans End 1932 Tennessee Game	96
Commodores Visit with President Franklin D. Roosevelt	101
Greer Ricketson's Historic Touchdown	104
Carl Hinkle Was an Iron Man	109
Bill Wade Became a Quarterback Legend	114
Dudley Field's First Night Game	120
The 1955 Gator Bowl	125
Vanderbilt Upsets Alabama in 1969	130
The 1974 Peach Bowl	136
Whit Taylor's Touchdown Defeats UT in 1982	141
The 1982 Hall of Fame Bowl	147
Appendix: All-Time Records	153
About the Author	159

FOREWORD

Would you like to take an enjoyable walk down memory lane with one of the South's premier sports historians? If that sounds like fun, you are going to relish Bill Traughber's latest work, this one a collection of Vanderbilt University football stories.

Traughber's collection of more than four hundred sports history features has been published locally in his hometown of Nashville, Tennessee, as well as for regional and national outlets. He knows athletics, and he has a special eye for the historical gem.

In his latest book, Traughber shares wonderful insights into many of the greatest Commodores players, biggest characters and memorable games. The book spans nearly one hundred years, beginning in the nineteenth century and including Vanderbilt's trips to bowl games.

Traughber's writing has been cited many times by the Tennessee Sports Writers Association. He has won Writer of the Year and Best Feature Writer awards from the organization since 2004. He has been in demand as a sports historian expert on the Tennessee mid-state speaker's circuit.

Among his many subjects are notables such as United States senators Fred Thompson and Lamar Alexander; Pat Boone, George "Goober" Lindsey and David Keith from the entertainment world; major league umpires; a Harlem Globetrotter; an Olympian; a professional wrestler; former NBA players; current and former professional baseball and football coaches and players; Tennessee Titans' players and coaches and a host of Southeastern Conference athletic icons.

Foreword

One reason that Traughber has become such a noted historian is that he keeps close tabs with the current sports scene, especially in Nashville, where he is a regular in area press boxes. He has contributed articles for the Nashville Sounds baseball club, Vanderbilt University football game programs, media guides and several websites. His earlier books have included *Nashville Sports History: Stories From the Stands* (2010) and *Brentwood Academy Football: From a Cow Pasture to a Tradition, 1970–2009* (2010).

If you would like to learn or remember about the origin of Vanderbilt football beginning with a challenge, a famous United States president visiting with the Commodores, Vanderbilt's hidden ball trick play that defeated LSU, the legend of Coach Dan McGugin, the first night game at Dudley Field and many other tales of yesteryear, this is your ticket to enjoyment.

Rod Williamson
Director of Vanderbilt Athletic Communications

PREFACE

My early recollection of Vanderbilt football was in August 1965, when I was eleven years old. My father took me and my twin brother to the Los Angeles Rams versus the Chicago Bears exhibition game on Dudley Field. I recall walking through an entrance into the stadium and seeing a green field with stripes and numbers. The big attraction to that game was the return of Bears' quarterback Bill Wade to Vanderbilt.

Wade was an all-American at Vanderbilt who scored two touchdowns in the 1963 NFL championship game to help the Bears defeat the Giants, 14–0. And thirty-four years after that exhibition game, when I was writing sports stories, I met Wade in his Nashville home for my research to interview him on his football career. We sat in his upstairs hallway searching through scrapbooks and photos. Wade was the first former Vanderbilt athlete I interviewed.

Vanderbilt University was founded in 1873 with a $1 million gift from "Commodore" Cornelius Vanderbilt. Athletics would become an important part of the college experience. As the eastern sport of football gradually invaded the southern states, Vanderbilt students were gathering for unorganized games by the late 1880s. Then, in 1890, the University of Nashville (Peabody Normal College) challenged Vanderbilt to a football game on Thanksgiving Day. Vanderbilt captain and fullback Elliott H. Jones organized a team that beat the crosstown rivals 40–0 at Sulphur Springs Park (later Sulphur Dell).

Preface

Jones would also serve as head coach for three years (1890–92), compiling records of 1-0, 3-1 and 4-4. With the growth of football in the South, additional college teams were gradually formed and schedules expanded. Vanderbilt became one of the stronger teams in the region. A football field was established on the Vanderbilt campus that was named for William L. Dudley, a promoter of athletics at the university. The original Dudley Field is presently the site of the Vanderbilt School of Law.

In 1904, Vanderbilt hired Dan McGugin as its new head football coach. He had played football at Michigan and was an assistant to Wolverine legend Fielding Yost. McGugin would achieve legendary status himself, remaining on the Vanderbilt campus for thirty years. His first team was 9-0-0, the only undefeated, untied team in Commodore history.

Vanderbilt football became so popular in Nashville that a new Dudley Field was constructed in 1922. It was the first football-only stadium in the South. Yost's Michigan squad was the opponent for the inaugural game, which saw the heavy underdog Commodores fight the Wolverines to a 0–0 draw. Captain Jess Neely led the way for Vanderbilt on that historic afternoon. McGugin retired from coaching in 1934 and died two years later. He is Vanderbilt's all-time winningest football coach with an amazing record of 197-55-19.

Vanderbilt produced many great players in this early era of Commodore football. Such players to gain national attention as all-Americans include Ray Morrison (1911), Josh Cody (1919), Lynn Bomar (1923), Henry Wakefield (1924), Bill Spears (1927), Pete Gracey (1932) and Carl Hinkle (1937). McGugin, Morrison, Bomar, Spears and Cody are also enshrined into the National College Football Hall of Fame.

With the retirement of McGugin after the 1934 season, Vanderbilt looked to former player Ray Morrison to continue the football success. As the decades passed, the Commodores could not find the success or dominance they once enjoyed.

Art Guepe's 1955 squad stunned no. 8 ranked Auburn, 25–13, in the 1955 Gator Bowl in Jacksonville, Florida. This was Vanderbilt's first bowl appearance as quarterback Don Orr ran for two touchdowns, and all-American fullback Charley Horton rushed for another six-pointer. The victorious Commodores concluded that historic season with an 8-3 record.

As Vanderbilt entered the 1960s, hard times would arrive on the football field. Only a few teams earned a winning record. In 1969, Vanderbilt broke the NCAA record (since broken many times) for most yardage in a game,

Preface

against Davidson. The Commodores amassed 798 yards in the 63–8 victory. Tailback Doug Mathews led the Commodores in rushing with 138 yards, while quarterback Watson Brown added 118 on the ground. Vanderbilt passed for 368 yards.

In 1973, twenty-eight-year-old Steve Sloan became the nation's youngest head coach, and the Vanderbilt campus was full of excitement. In Sloan's second and last season, he guided the 1974 Commodores to a Peach Bowl invitation with a 7-3 record. Vanderbilt kicker Mark Adams booted two field goals in the 6–6 defensive struggle with Texas Tech in the Atlanta bowl.

Fred Pancoast's (1975–78) Commodore club defeated Tennessee in Knoxville, 17–14, in his first year at the helm. That Vanderbilt team finished the season 7-4 but was unable to gain a bowl bid. In 1978, Vanderbilt running back Frank Mordica rushed for 321 yards against Air Force, breaking the SEC record. His record still tops the record book today. Mordica was the first Vanderbilt rusher to gain more than 1,000 rushing yards in a season and is the Commodores' leading career rusher with 2,632 yards.

In 1982, SEC Coach of the Year George MacIntyre (1979–85) led Vanderbilt to a winning season with an 8-4 record. The accomplishment secured a Hall of Fame Bowl bid in Birmingham. Vanderbilt quarterback Whit Taylor was named MVP in a 36–28 losing effort against Air Force. Taylor broke seven HOF bowl-passing records with his 38-of-51 performance totaling 452 yards.

Commodore all-Americans in this modern era include Bucky Curtis (1950), Chip Healy (1968), Bob Asher (1969), Barry Burton (1974), Allama Matthews (1982), Jim Arnold (1982), Chuck Scott (1983), Leonard Coleman (1983), Boo Mitchell (1988), Jamie Duncan (1997), Jamie Winborn (1999), Earl Bennett (2006) and D.J. Moore (2008). More football greats to wear the black and gold include Phil King, Tom Moore, Bob Goodrich, Pat Toomay, Will Wolford, Jay Chesley, Preston Brown, Carl Woods, Jamie O'Rouke, Chris Gaines, Kurt Page, Dennis Harrison, James Manley, Greg Zolman, Dan Stricker, Hunter Hillenmeyer and Moses Osemwegie.

In 2005, Coach Bobby Johnson's edition was led by quarterback Jay Cutler, who brought excitement to Commodore fans with his prolific passing. Jay Cutler earned SEC Offensive Player of the Year honors while being selected eleventh overall in the 2006 NFL draft. He is currently the starting quarterback for the Chicago Bears. Cutler leads Vanderbilt in all-time career passing (8,697 yards) and career total offense (9,953).

Preface

Vanderbilt appeared in the Nashville's Music City Bowl against Boston College in 2008. Kicker Brian Hahnfeldt booted a forty-five-yard field goal with 3:26 left in the fourth quarter for a 16–14 victory and a 7-6 record. Brett Upsom was the game's MVP with his outstanding punting.

I would like to recognize these present and former Vanderbilt Athletic Communications personnel: Rod Williamson (director), Larry Leathers (football contact), Chris Weinman, Andy Boggs, Kyle Parkinson, Ryan Schulz, Brandon Barca, Thomas Samuel, Tammy Boclair, Andre Foushee and Eric Jones, Vanderbilt's ticket manager.

The Vanderbilt Archives helped me with photographs and illustrations for this project and for my previous stories on vucommodores.com. I want to thank Henry Shipman, Philip Nagy Digital Imaging Specialists, and Juanita Murray, the Vanderbilt Archives director.

Though the Commodores have struggled in recent years to find the success on the gridiron as in early decades, Coach James Franklin has brought new energy and enthusiasm to the Vanderbilt football program in 2011. Vanderbilt football has a history to be proud of.

Go 'Dores!

VANDERBILT FOOTBALL BEGAN WITH A CHALLENGE

Dr. William L. Dudley, Vanderbilt University's president of the Vanderbilt Athletic Association, received a challenge that caused serious contemplation.

In November 1890, the University of Nashville (Peabody) communicated a challenge to Vanderbilt for a game of football. The association called for a meeting with the student body to decide how to uphold the university's pride with such an issue.

The proposed game was to be played on Thanksgiving Day, just two weeks away. The date would be an issue, since Peabody had participated in football as an intramural sport for several years and Vanderbilt had not.

The first published reference to football at Vanderbilt appeared in the 1887 edition of the college annual, the *Comet*:

> *Football has never obtained a foothold among us. There have been two reasons for this: first, the boys never have become interested in the game; second, when desiring to practice and organize teams, we have been unable to obtain playing grounds. We hope to soon have suitable grounds for playing a sport which will quickly grow into great popularity on its own merit.*

Despite these obstacles, a team did practice occasionally in the fall of 1886. Through the years of 1887, 1888 and 1889, there would be no mention of football in the Nashville newspapers or the *Comet*. During this era, football

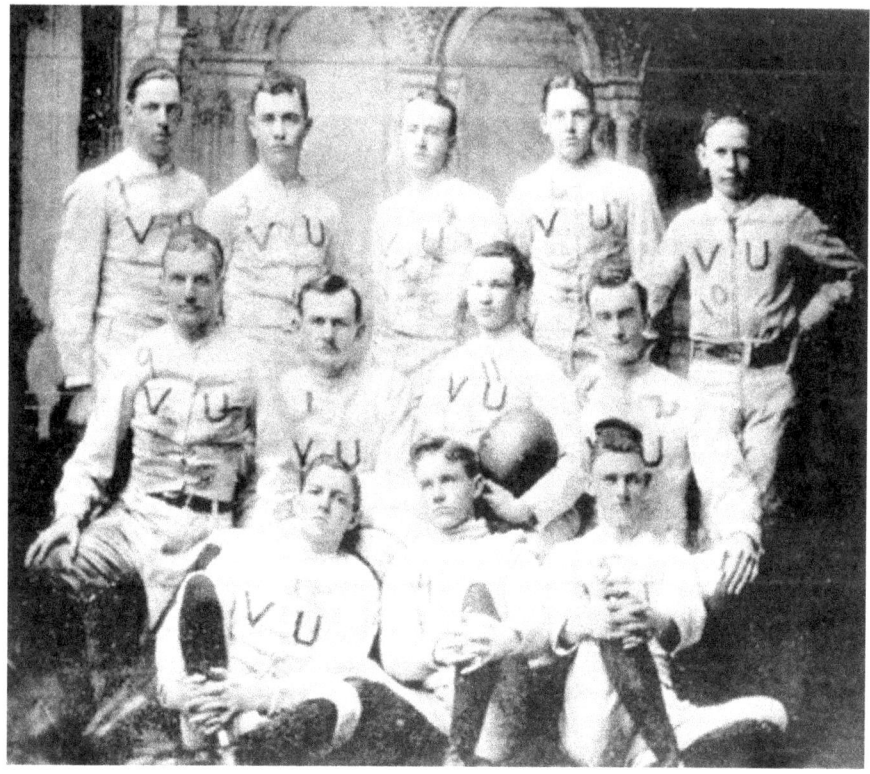

Vanderbilt's first football team in 1890 played one game, a 40–0 victory over the University of Nashville (Peabody). *Courtesy of Vanderbilt Athletic Communications.*

was a relatively new game played primarily in the East. College powers such as Princeton, Yale and Harvard dominated the game—its former players would introduce the game to other areas of the country. Football eventually spread into the South when in 1890 Virginia was the first southern team to play an intercollegiate game, losing to Princeton, 116–0.

A motion was made for Vanderbilt to accept the challenge, primarily since "Vanderbilt has never taken anything off of Peabody Normal and should not do so now." The motion was unanimously accepted, and Elliott H. Jones was authorized to organize, coach and captain a football team for this game.

After the meeting, Jones summoned all volunteers with football experience. Only five or six had such experience, but there were enough men to form a team. A regulation football was purchased, and with only a short time to prepare, practices consisted mostly of simple formations and signal drills.

Tales of Commodore Gridiron History

Jones was an innovative captain and acted on a suggestion that would become a constant aspect of preparing for football games. He gave this personal recollection many years later in the book *Fifty Years of Vanderbilt Football*:

> *This first game, on Thanksgiving Day, 1890, was played at Sulphur Dell, field of the professional baseball league, in North Nashville, said Jones. There was but one official an umpire or referee. I cannot now recall his name, but he had been a "crack" football player at Yale. He ran the game without any trouble. None of us knew enough to try to question any decision he made, although several of us had sat up nights studying the then rules of the game.*
>
> *Pat Estes suggested that we ought to "scout" the Normalites at play. So, one afternoon we took time off from practice to do the scouting job. We furtively perched ourselves in a tree adjacent to the football field of the Normalites—they actually had a field—and from that point of vantage we watched the play of their two teams for an hour or more, and got very useful information.*

Vanderbilt won its inaugural game at Athletic Park (later Sulphur Dell), 40-0, on November 27, 1890. Touchdowns were awarded four points, field goals and extra-points two points and a safety two points. The game received a little attention when the *Nashville Banner* gave the following account the next day:

> *A large number of people witnessed the game of football played yesterday at the Young Men's Christian Association Athletic Park by teams of Vanderbilt and Peabody Normal College. Mr. John C. Burch was the referee. The Vanderbilts won by a score of 40 to 0. No one was hurt seriously though some were more or less bruised. A game between the Vanderbilts and the University of Virginia is talked of.*

There was not a detailed summary or lineup of the game, and not a single player's name was mentioned. There was not a complete sports page, and without a popularity of this new game in the South, little space was given. Nashville historians have credited this game as the first football game played in Nashville. But an organized game in 1885 between the Nashville Athletic Club and Nashville Football Club was also played in Athletic Park.

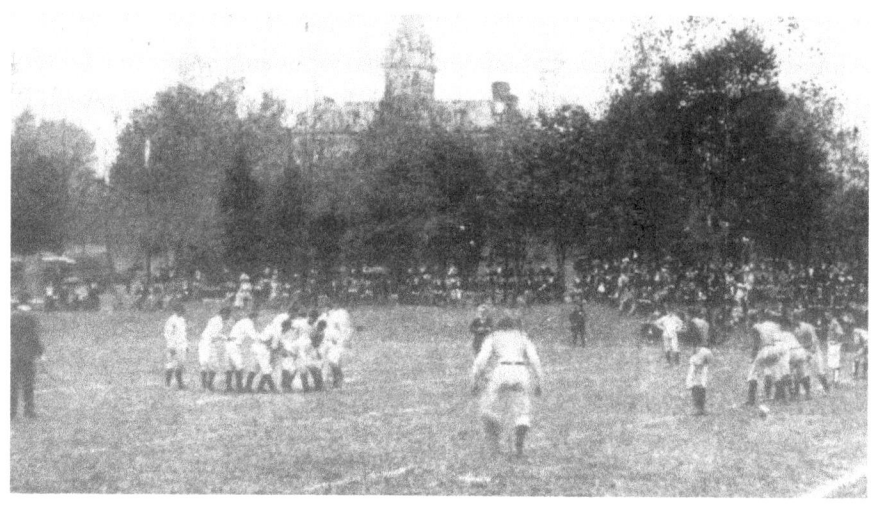

This action photo is from the first Vanderbilt versus Tennessee football in 1892. The Commodores won the game on the original Dudley Field, 22–4. *Courtesy of Vanderbilt Athletic Communications.*

Jones also recorded recollections of that first game:

> *Among the experienced men the most noteworthy, perhaps, were Horace E. Bemis, our crack quarter-miler, and R.H. Mitchell, a graduate of Trinity College, North Carolina. Mitchell had a way of squirming and twisting his way through opposing tackles and was a hard man to stop when sent through the line.*
>
> *Bemis was very fast, was an artful dodger, and was an expert in using the "stiff-arm" to throw off tacklers. We sent Bemis "around the end." He reeled off many runs of ten yards, twenty-five yards and more. If he once "got away" it was a pretty sight to see him go through a "broken-field." Bemis should probably be credited with three-fourths of the yardage which our team gained in our first game.*

The Peabody team actually outweighed Vanderbilt by twenty pounds per man. Vanderbilt gave credit to themselves for the lopsided win to brains and speed over brawn. Jones vividly remembered one Peabody player in particular:

> *I have little recollection about the players on the Normal team, with exception of one man, their fullback and captain,* Jones continued. *I can recall how he looked, and felt, as vividly as if the game was played on yesterday. He*

was over six feet in height, weighed about two hundred pounds, and was fast and powerful. I was playing fullback, and was the safety man on defense. Four or five times that fellow got by all but little me.

The first time that happened it looked like a futile thing for me to throw myself in the path of that charging giant. The old saying that "it is no disgrace to run when you are scared" seemed fully applicable. But it was up to me to try, even if in vain. It turned out that all he knew was to use speed and power. So, when I catapulted into him low and as hard as I could, he hit the ground like a ton of brick.

Sportsmanship is a part of the game never to be ignored. However, that evening after the game, an incident occurred that would bring embarrassment to Jones. A scheduled debating contest between Peabody and Vanderbilt took place in the Vanderbilt chapel. When the debate was concluded and the judges retired to reach a decision, some of the Vanderbilt players blackened the game ball. They chalked on the football "40 to 0" in large letters. The ball was then placed on top of the pulpit in plain view for all to see.

The presiding officer quickly removed the ball, but not before the entire audience saw it. The Vanderbilt students cheered, but the faculty members thought the prank was discourteous.

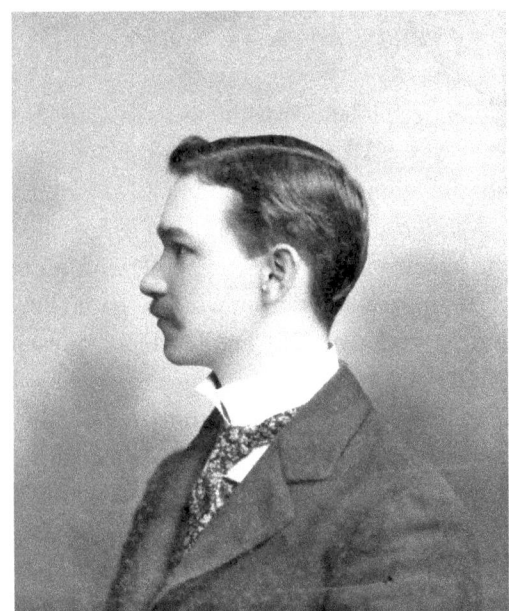

Elliott Jones organized Vanderbilt's first three football teams (1890–92) as head coach and player. *Courtesy of Vanderbilt University Special Collections and Archives.*

Vanderbilt Football

The 1891 season had Vanderbilt playing its first scheduled slate of games. Jones was also captain and coach but now was leading experienced and enthusiastic players. The schedule included two games with Sewanee and two games with Washington (St. Louis) on a home and away basis. Jones's team was 3-1 in this abbreviated season.

Jones also learned to master another aspect of coaching, pregame and halftime speeches. Just before the rematch game in St. Louis (Washington beat Vandy earlier, 26–4, in Nashville), Jones gave this pregame talk with a usual strategy, as told in *Fifty Years of Vanderbilt Football*:

> *While you fellows were enjoying your rest and sleep on the Pullman last night I stayed awake and did some thinking and planning. I have a definite plan of action. It is the only one in which I see any hope of success, and I want it rigidly adhered to. I take the responsibility for success or failure. Washington has a much heavier line than we have, but the weight is more fat than muscle. I propose that we do not try to advance the ball through that heavy line until we have worn them down.*
>
> *Our line is lighter, but we have more muscle, and I figure that we have better staying qualities. Therefore, I propose to play only on the defense during the first half. Everytime we get the ball I want Gardenhire to at once punt it as far down the field as he can. And I want you men to get down fast and see that the kick is not run back. I want to work the tongue out of those big, fat fellows in their line.*

Vanderbilt held Washington to a scoreless half. Jones's team did eventually wear down Washington and won the game 4–0 with a dominating short running game in the second half.

Vanderbilt's original Dudley Field located on the Vanderbilt campus was christened on October 21, 1892, with an encounter against the University of Tennessee. Vanderbilt won the game 22–4, with Jones scoring the game's first touchdown. Old Dudley Field, presently the site of the University's School of Law, would host gridiron games for thirty years.

William E. Beard, a quarterback on the 1892 team, first connected the name "Commodores" to Vanderbilt athletic teams when he was on the editorial staff of the *Nashville Banner* in 1897.

According to *Fifty Years of Vanderbilt Football*, "[O]pinions are divergent as to the reason for selection of Gold and Black as colors for Vanderbilt

teams. Some say that the original colors were Orange and Black, given the university by the late Judge W.L. Granbery of Princeton. Others credit the late Livingfield More with furnishing the colors of his Eastern prep school to the Commodores. The few remaining players of the 1980 squad do not recall why they suddenly appeared in Gold and Black."

Francis Craig was a member of the Vanderbilt class of 1924 and wrote the fight song "Dynamite." He was an avid Vanderbilt football follower who became a popular composer and longtime orchestra leader. Craig wrote the fight song on the Wednesday before the Tennessee game in 1938. It was first played publicly on WSM radio two nights after the game that was played in Knoxville. Vanderbilt students embraced the song. The original title was "When Vandy Starts to Fight."

SEWANEE WAS VANDERBILT'S FIRST RIVAL

Years before the University of Tennessee became the Commodores' main rival, there was Sewanee. Located on the mountain near Monteagle, Tennessee, Sewanee—also known as "the University of the South"—began playing football in 1891.

The team's first football game that autumn was against Vanderbilt. Vanderbilt was not at an advantage since it had begun its football program the year before with just one game, resulting in a 40–0 whipping of the University of Nashville (Peabody).

That first meeting was on the mountain, with the Commodores winning over Sewanee, 22–0. The *Nashville Banner* gave this partial report on the game:

> *The Vanderbilt football team went up to Sewanee Saturday and defeated the mountain boys rather easily, 22–0. The Vanderbilt boys played all around the Sewanee eleven, Allen, Jones and Craig especially distinguishing themselves by their brilliant work. The honors for Sewanee were carried off by the Cleveland brothers and Blackstock.*
>
> *The Vanderbilt boys were met at the Union Depot on their return at night by their fellow students and escorted them through the streets amid the wildest enthusiasm.*

Sewanee continues to play on that same historic field where its team lost to the Commodores on November 7, 1891. The original name of the

Tales of Commodore Gridiron History

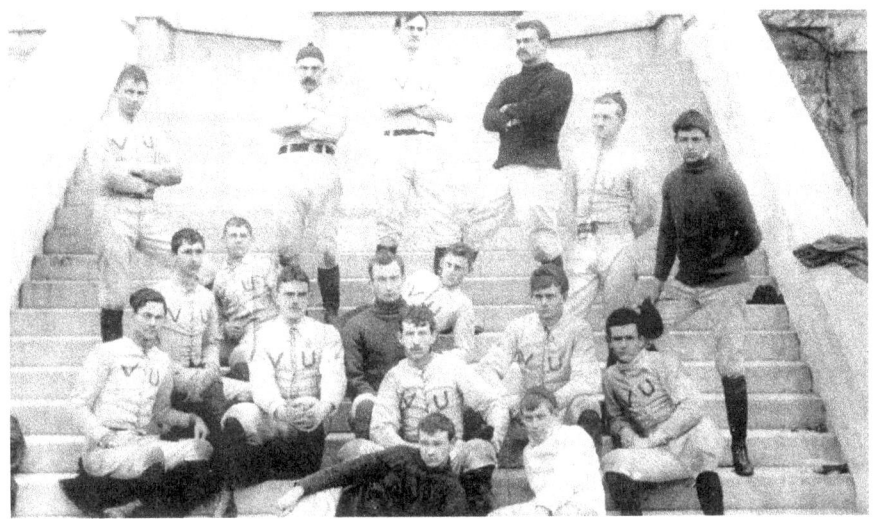

The 1891 Vanderbilt football team was 3-1 with two wins over Sewanee and a split in two games with Washington University (St. Louis). *Courtesy of Vanderbilt Athletic Communications.*

football field was Hardee Field, named for Confederate general William J. Hardee. It is the South's oldest football field and the nation's fourth-oldest NCAA field.

Just a few weeks later in 1891, Sewanee made a return visit to Nashville. That contest was played on Thanksgiving Day, and the Sewanee versus Vanderbilt game would become the social event of the season in Nashville.

Also, both schools were members of the Southern Intercollegiate Athletic Association (SIAA). Usually the Thanksgiving Day game in Nashville, or at Sewanee, was an influence on the outcome of the SIAA championship.

The *Nashville Banner* gave this report on that 1891 game played at Nashville's Athletic Park (later Sulphur Dell):

> *When the Vanderbilt and Sewanee elevens lined up at Athletic Park Thursday, they were greeted by the cheers of 2,000 spectators. Half the number were ladies who wore the colors of one of the rivals. The flying colors, combined with the general spirit of enthusiasm which prevailed the air, made up a scene long to be remembered and was one well-calculated to urge the players to their utmost endeavors. The Sewanee eleven, though in a strange city, did not lack for friends. A large delegation from the mountain accompanied the boys and cheered lustily.*

Vanderbilt Football

It was a fierce struggle all the way and a test of endurance, skill and strength in which the Vanderbilts demonstrated their superiority. Both teams averaged around 165 in weights. Sewanee showed weakness in guarding the ends and Vanderbilt was quick to grab the advantage. Gardenhire, Jones, Dortch, Barr and Sanders distinguished themselves, Gardenhire's first touchdown discouraged the Sewanee boys mightly. Mr. Miles of Sewanee and Mr. Keller of Vanderbilt acted as referee and umpire.

The next year would belong to Sewanee. Vanderbilt opened the season on the Sewanee campus with a 22–4 loss. In this era of football, a touchdown was worth four points. The game was knotted at 4–4 at halftime, but the Tigers dominated the second half. The newspapers of the day reported on a wild celebration on the mountain and that Vanderbilt was too confident and lax.

F.G. Sweat was the Sewanee coach in 1892, and his involvement with the return game at Vanderbilt was a concern. The *Banner* gave a commentary of Sewanee's second victory over the Commodores, 28–14: "The two teams were equally matched, but Sewanee was ably assisted by Mr. Sweat, who acted as umpire and who seemed unable to forget that he was the Sewanee coach. At critical points, while the Vanderbilts were so intent on their play that they could not hear him, he would encourage the Sewanees."

Before the two teams met again in 1893, the series was tied, with each club winning twice in four games. Another two-game series was played in 1893 in which Vanderbilt would claim a southern championship.

Vanderbilt won the first game at Sewanee with a hard-fought 10–8 result. The *Banner* reported:

What was perhaps the best game of football ever played in Tennessee was won by Vanderbilt at Sewanee Saturday, 10-8. Each side scored two touchdowns, but Sewanee filed at both tries for the goal and Vanderbilt kicked one. The intelligent coaching both sides have had during the early part of the season was in evidence in the superior tactics used by both. They were about evenly matched.

The Vanderbilt team returned to the city Saturday night and a howling mob of students made the principal streets resound with all sorts of discordant noises. Clanking bells and blaring horns were pleasant interludes to that awful chorus of brass lungs.

Tales of Commodore Gridiron History

Several weeks later, Sewanee was in Nashville for a Thanksgiving Day rematch at Vanderbilt. The *Banner* gave a report on the Commodores' 10–0 victory:

> *For a solid hour the battle raged without the slightest show of advantage. Then Sewanee weakened and by unrelenting wedges Vanderbilt drove them down the field. That's the story of the game. While both were fresh, neither was stronger.*
>
> *But Vanderbilt had greater staying powers. Both teams were in fine trim. Sewanee stared off by rushing to the 25-yard line, but fell back and Joe Goodson soon scored on a flying wedge. Later, Nelson of Sewanee fumbled a punt which led to the second touchdown, which broke Sewanee's backbone.*

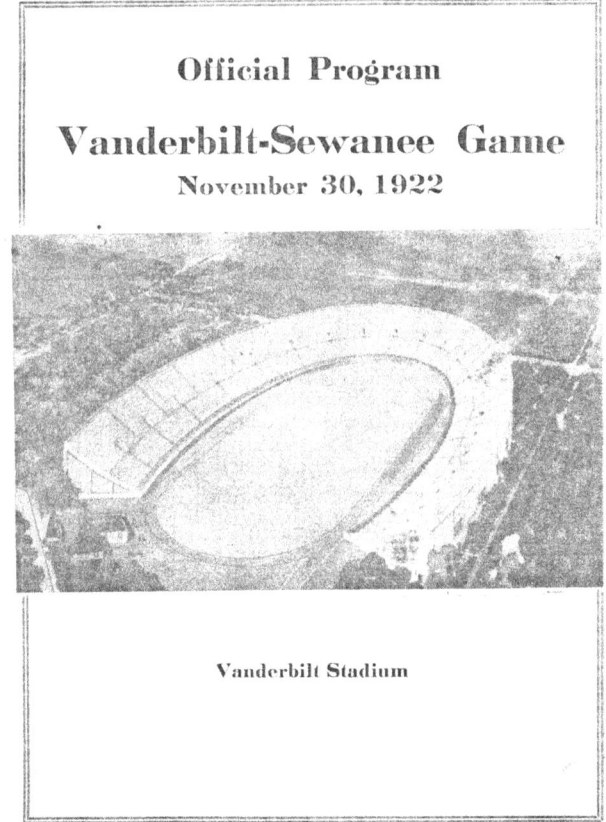

Vanderbilt first played Sewanee in 1891, with the last game in 1944. The Commodores were 41-7-4 all-time against the University of the South. *Courtesy of Vanderbilt University Special Collections and Archives.*

The Vanderbilt/Sewanee rivalry would last until 1944. The Commodores dominated the all-time series with a 41-7-4 record. At one time, Sewanee was a member of the Southeastern Conference, from 1933 through 1940. The Tigers were 0-37 in SEC play.

Sewanee has not played a major college football team since 1949, a 6–0 home loss to Florida State. The Tigers are members of the Southern Collegiate Athletic Conference at the NCAA Division III level. The Sewanee football field was renamed for Benjamin H. McGee in 1977.

On the press box of McGee Field is the bold lettering, "Yea, Sewanee's Right." That is the last line of an old Sewanee cheer that dates back to the 1890s: "Rip 'em up! Tear 'em up! Leave 'em in the lurch! Down with the Heathen! Up with the Church! Yea, Sewanee's Right! It is believed that the "Heathen" is possibly Vanderbilt, the heated intrastate rival. "Yea, Sewanee's Right" is now used as an alternative motto and is often shouted at the end of the university's alma mater.

Vanderbilt's first baseball game was in 1886, a 10–2 victory over Sewanee in Nashville. A second game with Sewanee that year went to Sewanee, 11–3. The Commodores would schedule Sewanee in baseball for two more decades, playing as many as six games per year.

Vanderbilt first played Sewanee in basketball in 1908, but most of those scheduled games came as a co-SEC member with the Commodores. Vanderbilt was 46-4 all-time against Sewanee in basketball.

NASHVILLE GAME ENDS WITH 1896 RIOT

Vanderbilt began playing football in 1890 with a 40–0 victory over the University of Nashville (Peabody). Nashville was a natural rival since the universities were several miles apart.

The students from both universities interrupted the 1896 game played at Vanderbilt. The *Nashville American* reported on the shameful melee with these headlines introducing the game story: "WAS MOST DISGRACEFUL, Local Students Appear in the Role of Hoodlums, Sideline Interference Breaks Up a Dragging Game, Vanderbilt and University of Nashville Foot Ball Contest Ends in Ugly Row which Started with Students." The *American* reported:

> *Vanderbilt athletic field was the scene yesterday of a very ugly affair, in which, the students of the local universities covered themselves with anything but glory. The University of Nashville men say that the slugging of the opposing eleven was the cause of disagreement, while the Vanderbilt men allege an unnecessary delaying of the game, during which the failing energies of the other side might be recuperated. Both of these reasons are, no doubt, true to a certain extent, but the prime cause was the bitter rivalry between the students of the two institutions.*
>
> *The exhibition of temper is much to be regretted, as it will affect not only the game, but will also hurt badly the reputation of each team. If a moment's thought had been given to the deplorable results which must inevitably follow it would have never occurred, but the cool heads were in*

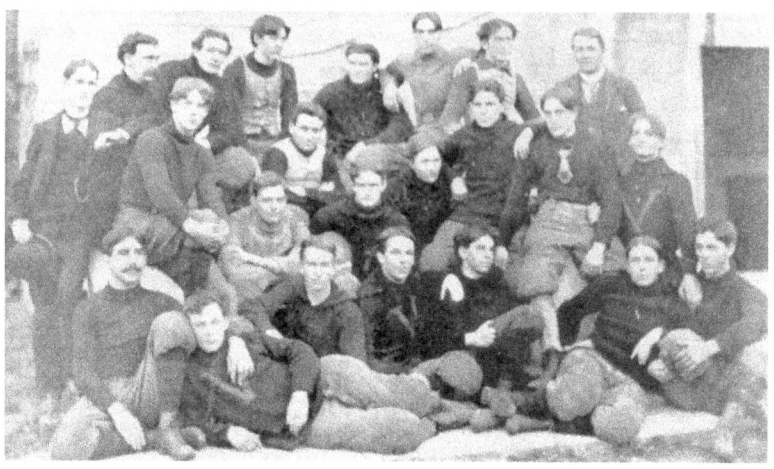

The 1896 Vanderbilt football team's record was 3-2-2, with the University of Nashville (Peabody) game ending in a controversial scoreless tie. *Courtesy of Vanderbilt Athletic Communications.*

> *the minority and were liberally punched when they attempted to advise a suspension of hostilities.*

The contention of debate was two plays that happened in the second half. Phil Connell of Vanderbilt attempted a drop kick for a field goal, but the ball traveled too low, hit the line and bounced away. Connell fell on the loose football, while Looney of Nashville fell on Connell "with considerable force, inflicting a large bruise upon his head."

Vanderbilt tackle Chuck Hassett pulled Looney off Connell "roughly, and the students appeared from both sides of the field, each body with the intention of seeing that its man got a fair play."

The *American* reported:

> *In a very short time words were supplanted by blows and for a few minutes both sides were engaged in a lively manner. After matters were amicably arranged the play was allowed to go on for a space of time, but a decision of the umpire being unsatisfactory to the University of Nashville, the men walked off the field, and while the two captains were discussing the matter the crowd came together again and necessitated a discontinuance of the game.*

It was decided by the umpire and referee to call the game on account of outside interference. Captains Connell and MacRae both expressed themselves as very sorry that the affair occurred and are of the opinion that it was due to the excited student bodies.

The second incident occurred in the second half and caused a controversy. With the game scoreless, Nashville captain John MacRae called for a timeout, which was not allowed. On the ensuing play, H. Davis of Vanderbilt ran the ball to the Nashville twenty-yard line. As the run by Davis was allowed, MacRae pulled his team off the field in protest and never returned.

So did Vanderbilt get the apparent forfeit victory? The *American* did not mention a forfeit and reported the game as 0–0. The manager of the Vanderbilt team, Granberry Jackson, sent this letter to the *American*:

> *As manager of the Vanderbilt football team I wish to enter a public protest against the above reported decision of the officials in the game this afternoon between Vanderbilt and the University of Nashville. It is there stated that the game was decided to be a draw on account of interference of outside parties, preventing the game from going on.*

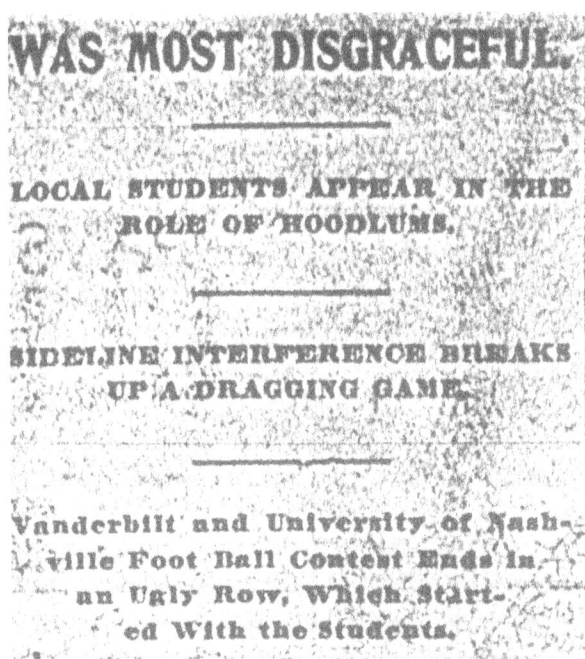

Newspaper headlines from the *Nashville American*. Courtesy of the author.

> *Whereas, it is a known fact to everyone present that the University of Nashville team left the field because of what they considered an unfair decision of the referee and refused to return within the limits provided by the rules. The Vanderbilt team during this time was lined up in position to play and the field was amply cleared for the game to proceed. I claim that by its failure to return to the field the University of Nashville team forfeited the game to Vanderbilt by the score allowed by the rules in such cases, 6–0.*

Of course, MacRae sent a letter to the *American* to explain the side from the University of Nashville's perspective:

> *I regret that so much time was taken out for University of Nashville players and want those interested in the game to know that the delay was caused by Vanderbilt's determined efforts to put our best men out of the game. Had the sluggers been disqualified when they were first detected in this dirty work the game would have ended differently.*
>
> *The University of Nashville men expected to be fouled and were instructed by their captain to play an especially clean game, and they followed his instructions. The conditions of some of our best men bear me out in my impression that they were being slugged in order to get them out of the game. The final decision is very satisfying under the circumstances. It would have been eminently unfair to call the game other than a draw at that stage of the game, for the conditions which made it best for us to leave the field were brought about by Vanderbilt's malicious foul play.*

A few days after the game, the Vanderbilt administration met to discuss the rough play and the disruptions that ensued. It was agreed that trouble could have been foreseen with the emotions of the two rival schools. The committee concluded that "only the merciful providence of God prevented results worse than black eyes and sore heads."

One Vanderbilt player was banned from playing football at Vanderbilt forever, and one was suspended for the rest of the season. The names were not mentioned. Administrators from both schools met, and it was decided that the game should be forfeited to the Commodores. Vanderbilt claimed a 6–0 win by forfeit.

Vanderbilt finished the season with a record of 4-2-1.

DAN MCGUGIN BECAME A COACHING LEGEND

On October 1, 1904, Mississippi State played a football game in Nashville and was thrashed by the Commodores, 61–0. That was also the day that a new coach, Dan McGugin, appeared on the Commodore sidelines and would become a coaching legend not only at Vanderbilt but also in the South.

McGugin would spend the next thirty years leading the Commodore football program and acquiring an amazing record of 197-55-19. He served one year (1918) in World War I. At Vanderbilt, he began as part-time coach and, in the interim, was a corporate lawyer.

McGugin was born in Tingley, Iowa, on July 29, 1879. He played one year of football at Drake University and three years at Michigan. McGugin was a guard on the Michigan team that played in the first Rose Bowl (Michigan 49–0 over Stanford) on January 1, 1902. McGugin earned his law degree from Michigan.

After his graduation from Michigan, Wolverine head football coach Fielding Yost was asked by Vanderbilt to recommend a football coach. While not having any head coaching experience, Yost saw something in McGugin to recommend him to Vanderbilt. McGugin had been an assistant to Yost.

In his latter years, McGugin told the story about how he came to Vanderbilt:

> *I wrote Vanderbilt, cautiously offering my services, but received no response. One day while the J-Hop was going on in Ann Arbor, I had a telegram*

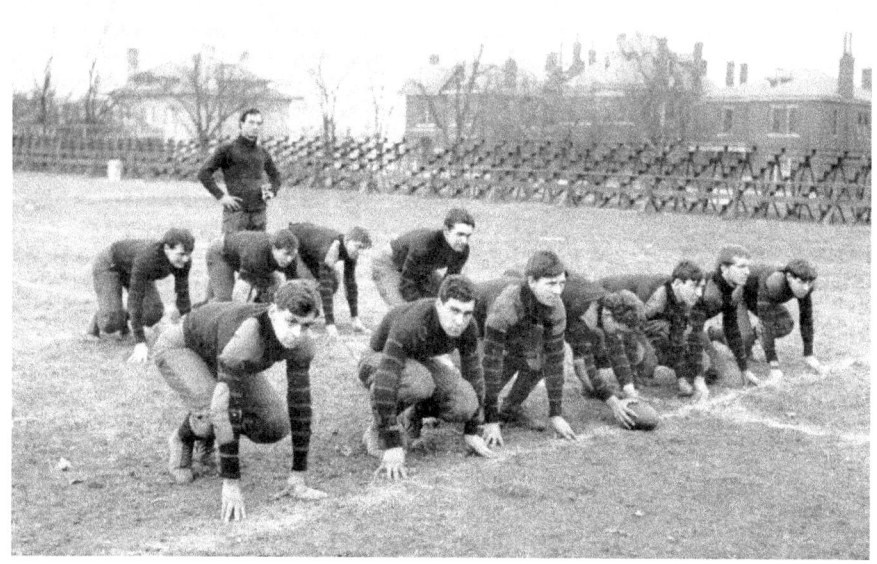

Coach Dan McGugin (standing) oversees a play with his offense, circa 1915. *Courtesy of Vanderbilt Athletic Communications.*

from Western Reserve at Cleveland offering me the job there and asking for an immediate reply. I went to the telegraph office and wired acceptance, and when I walked back to the Delta Upsilon house, I found a telegram from Vanderbilt definitely offering me that place.

Vanderbilt offered $850 and Western Reserve $1,000, but I wanted to come South and see and know the people. I decided that if I could recall the telegram to Cleveland before its delivery, I would go to Vanderbilt. Otherwise I would go to Western Reserve. The telegram was recalled before delivery by three minutes.

Shortly after arriving in Nashville, McGugin married Virginia Fite, with Yost serving as best man. Yost met Fite's sister, and he later married her. Now the close friends were related by marriage.

For a number of years the couple lived at 310 Twenty-fifth Avenue South, and their home was open to players and friends of Vanderbilt. McGugin was a disciplinarian who demanded respect, and it was said that he never used "rough" language nor berated a player publicly.

Tales of Commodore Gridiron History

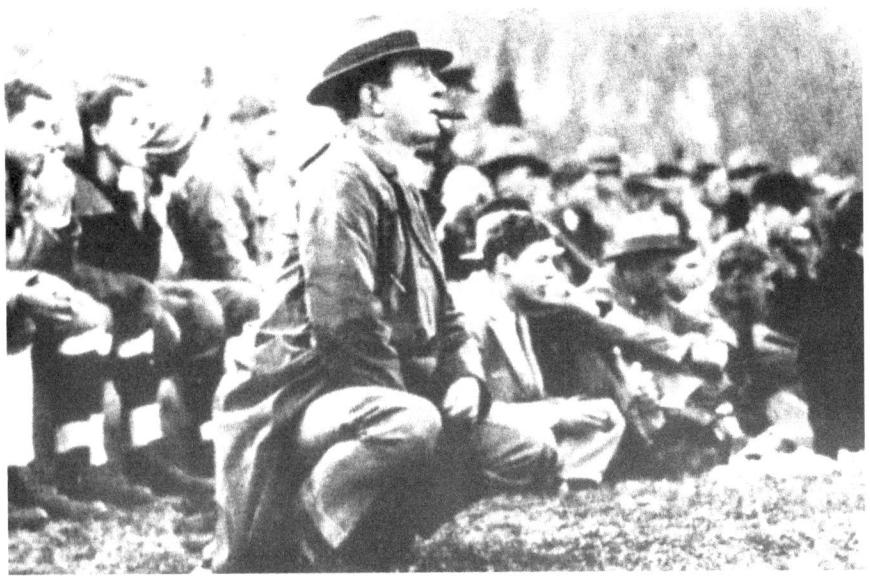

Coach Dan McGugin watches the game action from his customary view from the sideline. *Courtesy of Vanderbilt Athletic Communications.*

In his first season at Vanderbilt, the 1904 squad was 9-0-0, the only undefeated, untied team in Commodore history. Eight of those games were shutouts, the only opponent able to score being Missouri Mines (29–4). Vanderbilt outscored opponents 452-4 to lead the nation in scoring that season.

McGugin's most memorable football game was the October 14, 1922 match in Nashville against his friend and brother-in-law: Yost's Michigan team. Michigan was the heavy favorite to win the game. The game was the first at the new Dudley Field (present site), and the contest ended 0–0.

It was reported that before the Michigan game McGugin said to his players who were gathered before the game, "You are going against Yankees, some of whose grandfathers killed your grandfathers in the Civil War." It was not known if the players knew that McGugin's father was an officer in the Union army.

McGugin recorded three seasons (1910, 1921 and 1922) with no defeats and one tie. In five seasons (1905, 1906, 1911, 1915 and 1926) his teams only lost one game on the schedule. He was 13-8-3 all-time against Tennessee, with most of those losses occurring near his retirement.

McGugin was known as a brilliant strategist with the ability to motivate his men. One such method was privately demonstrated before a big game.

Vanderbilt Football

Former Vanderbilt all-American Pete Gracey told this story about his coach that appeared in Fred Russell's book *Bury Me in an Old Pressbox*:

> *In my first varsity year, the night before we played Georgia Tech, Coach McGugin casually walked up to me in the lobby of our hotel, put his arm around my soldier and sorta whispered, "I was with some Atlanta newspapermen this afternoon and I told them you were the finest sophomore center I had ever coached. I hope that I haven't made it embarrassing for you."*
>
> *We beat Tech, 49 to 7. Afterward I talked to seven other players and you know, Coach McGugin told them all the same thing he told me.*

McGugin is credited with being the first coach to use the onside kick effectively when the rules were changed, as well as using guards to pull to lead interference. Under McGugin's guidance, Vanderbilt became the first southern team to play intersectional games.

Legendary sports writer Grantland Rice began his writing career in Nashville and was a longtime personal friend of McGugin's. Rice gave this tribute to his friend:

> *I have known a long parade of football coaches through the past forty years, but I have never met one who combined more of the qualities needed to make a great coach than Dan McGugin carried.*
>
> *In the first place Dan knew the fundamentals and knew how to teach them. In the second place he knew plays that a team needs for its scoring record. Above all he was a fine inspirational, one who always had the complete affection and respect of his players. I don't believe many people know the amazing job Dan McGugin did along this latter time. I have heard any number of old Vanderbilt players tell how much he had meant to their lives after college days were over.*
>
> *Dan had a keen sense of humor that is a big factor in bringing about periods of relaxation which every football squad must have. Few coaches ever had better ability at keying up the team, for Dan had a psychology of his own which seemed to fit changing occasions.*
>
> *His thirty year record at Vanderbilt will stand as one of the finest things in football, when you take into consideration his success as a coach, and his greater success as a builder of character.*

Tales of Commodore Gridiron History

Upon his retirement from active coaching in 1934, Dan McGugin was the oldest coach in America in terms of service (thirty years) with one institution. *Courtesy of Vanderbilt Athletic Communications.*

McGugin retired from coaching after the 1934 season. His last four teams were 5-4, 6-1-2, 4-3-3 and 6-3. McGugin continued to practice law while also serving as Vanderbilt's athletics director. At the time of McGugin's retirement, he was the oldest coach in America as far as service with one institution.

As a Nashville citizen, McGugin gave himself to the community. McGugin was a trustee of Fisk University, a member of the Vine Street Christian Church and a Belle Meade Club member, as well as was active in the Boy Scouts organization.

McGugin died on January 23, 1936, at the home of his law partner. He was fifty-six and remains the winningest football coach in Vanderbilt history.

McGugin was a president of the American Football Coaches Association, a member of the Iowa Sports Hall of Fame and, posthumously, of the National Football College Hall of Fame.

McGugin is buried in Nashville's Mount Olivet Cemetery.

FAMOUS CARLISLE INDIANS PLAY VANDERBILT

On Thanksgiving Day, November 22, 1906, Nashville hosted its first battle between the Cowboys and Indians. That's when Vanderbilt University added the famous Carlisle Indian School to its schedule.

The Vanderbilt football team needed to fill an open date on its slate. The powerful Carlisle Indians, from Pennsylvania, negotiated a trip to Nashville just one week before the game was to be played on Thanksgiving. The game was played on the old Dudley Field (present site of the Vanderbilt School of Law).

The *Nashville Banner* predicted that this would be "the greatest game the South ever saw." Excitement was rampant as the *Banner* reported:

> The greatest crowd ever seen on Dudley Field will undoubtedly be out for the game. As many seats as can be placed on the four sides of the field will be provided. In addition to those already up others will be put up on the south end. There will in this way be almost 5,000 seats.
>
> There is but little if any doubt that there will be more than 5,000 persons who will want to see the game, as many who never go to the football games have a curiosity to see the famous Carlisle Indians. While curiosity to see the Indians play the white man at his own game, and to play him wonderfully well, will draw out a large part of the crowd, the fact is that the contest is certain to be a corking good one.

Tales of Commodore Gridiron History

CARLISLE INDIANS TO BE HERE THURSDAY TO PLAY VANDERBILT

Negotiations Concluded and Seats Now on Sale—No General Admission Tickets; All Seats Reserved—Greatest Game South Ever Saw—Largest Crowd Ever Gathered on Dudley Field Sure to Witness Great Contest.

An ad in the November 17, 1906 edition of the *Nashville Banner* announces the last-minute addition of the famous Carlisle Indians to the Vanderbilt football schedule. *Courtesy of the author.*

The Carlisle Indian School had opened its doors in 1879 on the grounds of an old army barracks in Carlisle, Pennsylvania. The institution was funded by the Department of the Interior and the War Department to enable any American Indian to receive an education. Athletics became an important part of the school's activities.

Football was played, but not very well in the early years. It wouldn't be until legendary coach Glenn S. "Pop" Warner was hired to bring the team into prominence. While at Carlisle, from 1899 until 1903, Warner built the football program into one of the most elite in the East.

Warner was an all-American guard from Cornell, with his coaching experiences including Iowa State, Georgia and Cornell. He left Carlisle at the end of the 1903 season after laying the foundation for a football dynasty. Warner would return to Carlisle in 1907 and continue as head coach through 1914. In this second stint as head coach, he would bring in the great Jim Thorpe and enable Carlisle's greatest achievements on the gridiron.

Bemus Pierce coached the 1906 Indians, while Dan McGugin led the Commodores. The *Nashville Banner* reported that the Indians were the first eastern school to visit the South for a football game. Special trains brought sports writers and fans to the city from all over the South.

The intersectional battle did not disappoint the stadium crowd, as all predictions came true. The *Nashville Banner* reported that evening on the game with the politically incorrect front-page headline: "Red Skins Taste Bitter Defeat at Hands of Pale Face Commodores." The *Banner* reported:

Vanderbilt Football

Vanderbilt outplayed the Carlisle Indians this afternoon on Dudley Field in every department of the game and won, 4 to 0, a goal from the field by Bob Blake being the only score made. The contest was the best ever played on Dudley Field and was witnessed by 8,000 persons or more. This puts Vanderbilt in a class with the big teams of the East and West as well.

The Indians came on the field at 2:35 and were given a rousing cheer and three "rahs." The regulars all had on their gold sweaters, with big red "C.S." on them. The subs were all wrapped in red blankets and carried extra ones for the regulars. The band joined in the welcome to the red men by playing "Hiawatha." The men ran signals until the Commodores appeared.

The Commodores came on the field five minutes later and enthusiasm broke loose, the band joining in with Dixie.

Vanderbilt's Bob Blake made a field goal just before the first half ended. A field goal was worth four points in this era of college football. The *Banner* describes the game-winner: "Bob Blake drops back for a place-kick. The ball is now on the Indians' 17-yard line. The silence is oppressive at this point. Costen builds him up a little mound. The ball is sent back by Stone, and Bob Blake's good right foot sends it squarely between the goal posts."

The game started about forty-five minutes late in order to accommodate the overflowing crowd. The special game required a reserve ticket to witness the contest. General admissions tickets were not available, a rarity for Vanderbilt football games. Tickets were priced at $1.00 and $1.50 each. "Boxes, for four persons, will be $10, and auto spaces the same," the *Banner* announced before the game.

The Carlisle star player was Frank Mt. Pleasant. The halfback led the Indians down the field after taking the opening kick. They marched down to Vandy's three-yard line before being stopped by a stubborn Commodore defense. Carlisle never threatened to score the rest of the day.

The game was primarily a punting duel between the clubs. The game received such attention that Georgia Tech coach John Heisman attended the game. The namesake of the annual trophy for college football's best player wrote a column for the Atlanta's newspapers about the game. John Heisman wrote:

Magnificent is the fitting word to stamp their play. Manier bucked the Indians' line. Costen handled the ball surely and well downed Mt. Pleasant

Tales of Commodore Gridiron History

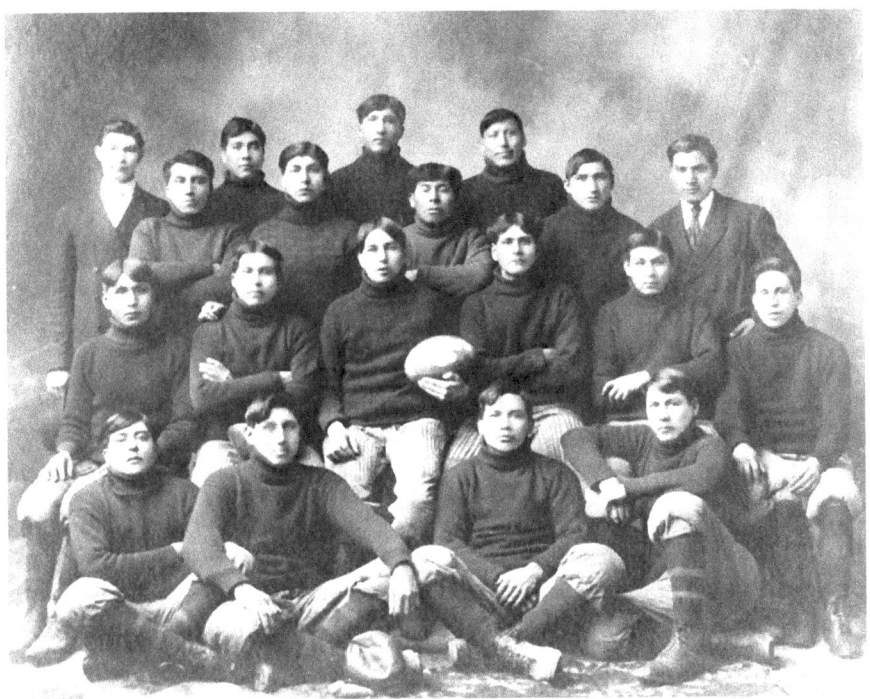

The 1906 football team from the Carlisle Indian School was billed as the greatest game ever played in the South. Vanderbilt won the game, 4–0. *Courtesy of Cumberland County Historical Society, Carlisle, Pennsylvania.*

> in his tracks on most of Blake's punts. Costen handled punts better and the whole Vanderbilt defense was fiercer and sharper than the Indians.
>
> I am still convinced that outside Yale and Princeton, the Commodores would have an even break with any other team in the country. That is a great deal for Vanderbilt, and for the entire South. It lifts us all a few notches higher. Furthermore, I have no hesitation in saying that Vanderbilt should have won by a bigger score.

Pierce's Carlisle team finished that 1906 season with a record of 9-2. The Indians scored 244 points while giving up just 36 tallies. The Commodores concluded that year at 8-1. Their lone defeat was a bruising 10–4 loss at Michigan. Seven of those victories were shutouts.

When Warner left the Indian school in 1914, after rejoining in 1907, the football program began to decline. As more nonreservation schools opened in the West, it was no longer necessary for Indians to travel east for

an education. As the enrollment dwindled, the football team could not be competitive and had losing records.

The outbreak of World War I necessitated the War Department's exercising its right to gain control of the school as it had originally. The remaining students were sent home or to other schools in the West. The Carlisle Indian School officially closed its doors on September 1, 1918.

Today the historic "Carlisle Barracks" is home to the U.S. Army College and U.S. Army Military History Research Collection. The original Indian athletic field can be seen as part of a self-guided tour.

According to *Favorite Football Stories*, Pop Warner could be heard motivating one of his Carlisle teams: "From the shores of the Little Big Horn to the banks of Wounded Knee, the spirits of your people call to you today. The men who died in Chief Joseph's retreat over the mountain, the Cherokees who marched on bloody feet through snow out of their ancestral lands, tell you you must win. These men playing against you today are soldiers. These are the long knives. You are Indians. Tonight we will know whether or not you are warriors."

Vanderbilt Ties Powerful Yale in 1910

On October 22, 1910, Vanderbilt made a venture up north to play the powerful Yale Bulldogs in New Haven, Connecticut. Yale had gone through the 1909 season undefeated and unscored on. The northern power was loaded with all-Americans. The game was also special because Yale was playing a southern team for the first time in its history.

The day was murky, a light rain fell on the field for most of the game and Vanderbilt was a heavy underdog. The Commodores were coached by Dan McGugin and led by quarterback Ray Morrison. Vanderbilt entered the game undefeated with a 4-0 record and also unscored on. The *Nashville Tennessean* gave this partial report on the game:

> *The Gold and Black tonight floats side by side with Yale's disconsolate Blue. The score was 0 to 0, in forty-eight minutes of actual play. Expecting to avoid last week's disaster the big Blue machine fought fiercely, but in place of winning suddenly, found that it needed the hardest sort of effort to prevent being scored upon.*
>
> *Not only did Vanderbilt repeatedly stand off the heavier Yale rushes at her own goal line but to the big surprise of the Eli supporters and team, the light southerners, play after play fought their way through the Yale line, circled her ends or flashed forward passes that bewildered the New Haven giants and kept them guessing throughout. Vanderbilt displayed a strong, consistent attack, with fine variety and employed with fine judgment.*

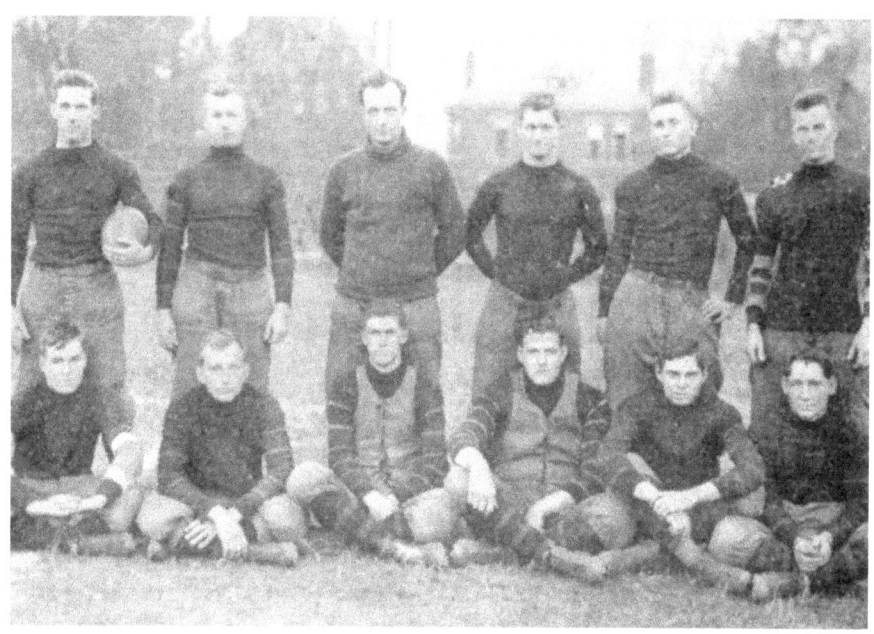

These eleven Vanderbilt football players (with Coach Dan McGugin, standing, third from left) brought recognition that the southern universities could compete with the powerful eastern schools. They played the entire match without a substitution in the 0–0 game in New Haven. *Courtesy of Vanderbilt Athletic Communications.*

It was easy enough to see at the start that the southerners had made up their minds to give Yale a fight to remember, whoever won. Both the line and the backfield were on the jump, overlooking no openings and at all times playing with the finest possible sprit. When Yale had chances to rush the ball over the six-yard line, the entire Vanderbilt eleven seemed to be, upon the man with the ball, rolling back the attack with a power hardly to be expected from an eleven fifteen pounds lighter to the man.

The deadlocked game sent shockwaves throughout the North and the South. Newspapers gave the opinion that the Vanderbilt win closed the gap between the two sections of the country. Football began in the North and had spread into the South. In this era, Yale and the Ivy League schools were considered the best in the nation.

That was the first home game in which Yale had failed to score a point. A special report appeared in the *Tennessean* praising the historic effort:

Tales of Commodore Gridiron History

The showing made by the entire eleven is deserving of the highest phrase. Individually and collectively, with Dan McGugin at the helm, they have all shown the eastern wing of the continent that football is gradually obtaining a foothold in the south—that off and on they play an imitation of the real stuff down this way, and are slowly but surely edging toward the map. Dan McGugin has shown that he was able to cope with the best array of talent in the east—and with but one assistant—Bob Blake—has been able to furnish a few general sidelines they have not yet grasped.

Considering the odds he faced, the Commodore wizard has achieved the finest victory of his great career. From the team, the work of Neely and Morrison stands out, but the detail shows that every man did his duty and added something for extra measure—that Brown and Stewart at ends were in the thick of every fray, and that the muchly abused line fought like wildcats in rolling back the Blue advance when a touchdown threatened. The detail shows that the entire eleven fought without faltering to a game finish—defending its goal and then smashing its way into Yale territory with a rush that sent the drenched Blue flags fluttering limply to half-mast.

From being held as a weak eleven, the Vanderbilt delegation arrives home Monday awaiting the greatest welcome and the most deserved that ever fell to the lot of any legion battling beneath the standard of Gold and Black. For so far they have written the brightest page inscribed in the history of the southern game.

The following quotes came after the game.

Yale head coach Ted Coy: "It is needless to say that I was greatly surprised and disappointed at the result. But for all that, I have no excuses to make. When Vanderbilt first came on the field I did not believe they were heavy enough to stop us, but her men fought with splendid spirit and were apparently excellently coached in every department of the game."

Coach McGugin: "Vanderbilt teams have never developed the habit of making a spectacle of themselves away from home. I had no hope of the boys turning such a trick, but knew they would fight to the last. No team ever worked with a finer spirit and no team I ever saw deserves the credit Vanderbilt eleven deserves for making such a stand against such obstacles. Every man on the squad simply went in like a tiger, and there was no let-up. They put every ounce of fighting strength they had into every play."

Vanderbilt Football

Bill Neely was an all-Southern player and captain of the 1910 Vanderbilt football team. *Courtesy of Vanderbilt Athletic Communications.*

Captain Daly of Yale: "We played the best we knew how, but were not strong enough to win. That's about all there is to say. We were not looking for any such resistance nor for such a well-trained machine. Vanderbilt played good hard football and we have no complaint to offer that the game was a draw."

Captain Bill Neely of Vanderbilt: "The score tells the story a good deal better than I can. All I want to say is that I never saw a football team fight any harder at every point than Vanderbilt fought today—line, ends and backfield. We went in to give Yale the best we had, and I think we about did it."

Vanderbilt finished the 1910 campaign with an 8-0-1 record.

Grantland Rice, a Vanderbilt graduate and sports writer for the *Tennessean*, could not help but to write one of his famous poems concerning the Vanderbilt/Yale game:

These are the gladdest of possible words,
"Yale Was Unable to Score,"

Tales of Commodore Gridiron History

> *Sweeter than song from the clear singing birds,*
> *"Yale Was Unable to Score,"*
> *Words that are sweeter than nectar and honey,*
> *Sweeter by far than the jungle of money,*
> *Words that are roseate, golden and sunny,*
> *"Yale Was Unable to Score,"*
> *Find in the classics another such phrase,*
> *"Commodores Draw with the Blue,"*
> *Phrase that is all to the ripple and razzle,*
> *Canonized cluster of words on the dazzle,*
> *Words that have Emerson smashed to a frazzle,*
> *"Commodores Draw with the Blue."*

Back in Nashville on the night of the big victory, more than one thousand Vanderbilt (male) students, "clad in nightshirts, pajamas and curtailed bonnets," celebrated with a parade march through the streets of Nashville. The *Tennessean* reported on the cheerful students after their downtown trip of songs and cheers, which included a stop at the Hermitage Hotel:

> *In an evil moment somebody said Belmont. That was enough. They were off in a bunch for the female college. It took sometime for the long line to get all the way to Belmont, but when they finally arrived, their sprits were fairly effervescing, and they gave all the yules and songs in the deck, then added a few extemporaneous ones. After the girls had had their treat, the parade went back to the campus and a bonfire was built on Dudley Field, where the boys in nighties stayed until far past the hour for young persons of tender years to be up.*

Boys will be boys!

RAY MORRISON, A PLAYER AND COACH

Ray Morrison (1908–11) is considered one of Vanderbilt's greatest quarterbacks in its long football history. As a player, Morrison was measured as courageous, loyal, inventive and resourceful.

Morrison was born in Sugar Branch, Indiana, on February 28, 1885. Less than a year later, the Morrison family settled on a farm near McKenzie, Tennessee. While working his farm chores, Morrison attended the McKenzie grammar and high schools. Morrison also followed his high school work with a year at McTyiere School for Boys.

Needing funds for college, the ambitious Morrison worked a year on a dredge boat on the Mississippi River. Upon entering Vanderbilt University, the future great athlete weighed only 155 pounds. Morrison would become one of the South's greatest broken field runners as a quarterback and halfback.

In 1910, Morrison led his Commodores to New Haven, Connecticut, to face the mighty men from Yale University. In this era of college football, the eastern schools fielded the best teams while the southern teams gained little respect. Before a kickoff, the Bulldog players would shout at the opposing Commodores, "Hey there, Rube, how's your plantation?"

In the end, Vanderbilt shocked the college football world with a 0–0 tie. Morrison was brilliant in his play helping to keep the ball away from the mighty Yale offense. The Yale coach, Ted Coy, said after the game that Morrison was "the greatest player I have seen in years." In his four seasons in a Commodore uniform, Morrison helped Vanderbilt to a 30-

6-2 record. He was selected as an all-American in 1911.

"As the whistle blew for the finish of the game," wrote Jack Nye in the *Banner*, "Ray Morrison was presented with the game ball by one of his teammates and tucking it under his arm as a priceless treasure, he walked off the field for the last time as a member of a Vanderbilt team. There was not one of the spectators who did not experience a tinge of sadness as they saw the little hero bid farewell to Southern football." During the annual banquet, Coach Dan McGugin stated that Morrison was the best quarterback he ever saw in his life.

After graduating Vanderbilt, Morrison became a teacher and athletics director at Branham & Hughes Military Academy in Spring Hill, Tennessee. He stayed at the school from 1912 until 1915. Morrison next found himself at Southern Methodist University (1915–16) in Dallas, Texas. At SMU, he was responsible for coaching football, basketball, baseball and track while supervising the physical training of all of the school's men and women.

The year 1915 was also the first year the SMU campus was opened for students. Morrison was the school's first head football coach and held the first practice one week before the first game with only freshmen players. Morrison was 2-5 that first year, with a two-year total of 2-13-2.

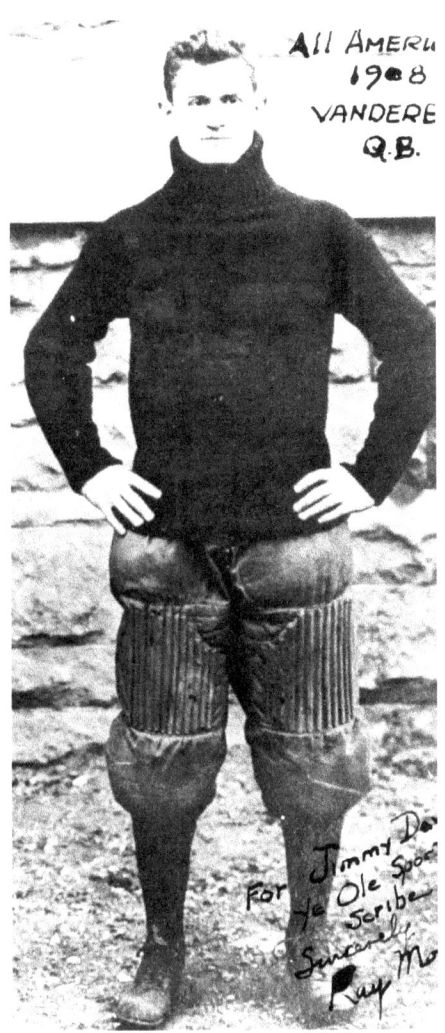

Ray Morrison was an all-American quarterback for Vanderbilt in 1911. He was inducted into the College Football Hall of Fame in 1954. *Courtesy of Vanderbilt Athletic Communications.*

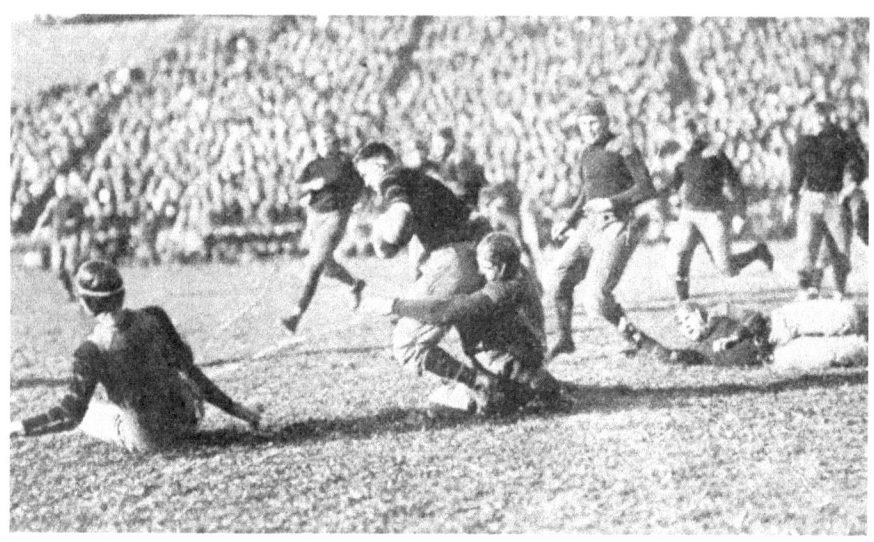

Ray Morrison being tackled in a game against Michigan in Ann Arbor in 1911. *Courtesy of Vanderbilt Athletic Communications.*

With the United States' involvement in World War I, Morrison went to Fort Oglethorpe in 1917. Morrison came to Vanderbilt as interim head football coach in 1918, when McGugin served one year in the military. Playing an abbreviated schedule, the 1918 Commodores were 4-2, with victories over Kentucky, Tennessee, Auburn and Sewanee. Losses were to Camp Greenleaf and Camp Hancock.

Upon McGugin's return to the Vanderbilt campus, Morrison spent a year at Gulf Coast Military Academy as athletics director and a teacher. In 1920, he was back at SMU, where he was freshman football coach for two years before taking over the head coaching duties.

Morrison's second stint (1922–34) with SMU was very successful. In thirteen seasons, he guided the Mustangs to an 82-39-17 record (84-44-22 overall in both stints). Morrison won three Southwest Conference championships in 1923, 1926 and 1931. His SMU teams were the first to use the passing game as an offensive weapon. Most teams threw the ball on third down when in desperation. Morrison also threw the pass on first and second downs from any position on the field.

Morrison's passing game earned him the title of "Father of the Forward Pass." Morrison's exciting exploits with the passing game created college football's first "Aerial Circus." His 1928 edition tossed for an astonishing

sixteen of thirty passes in a tough 14–13 loss to powerful Army, who threw just four passes.

When McGugin retired from coaching after the 1934 season, Morrison resigned from SMU to return to Nashville. Morrison was McGugin's handpicked successor. It would be a difficult assignment to replace the legendary McGugin, who coached thirty years for the Commodores. Fred Russell of the *Banner* wrote the following upon Morrison's trip to his alma mater:

> *Ray Morrison, Vanderbilt's new head coach, Tuesday made his first visit to Nashville since accepting the position as successor to Dan McGugin. Thirty minutes conversation with him produced these impressions.*
>
> *A gentle, soft-spoken person who talks out of the side of his mouth with convincing firmness. Eyes with a permanent twinkle, tiny wrinkles about them when he smiles, but a set jaw that seems to enclose teeth constantly gritted tighter. A happy combination that blends austerity and affability into well-nigh perfect personality—that's the Ray Morrison of today who was known to Nashvillians twenty-five years ago as Vanderbilt's whirling quarterback.*
>
> *Ray Morrison doesn't look like the average coach. He has a scholarly appearance, and after all, that's quite natural. Wasn't he a bit of a scholar in his undergraduate days? Yes, you imagine him as the hero of some of those stories you read as a kid. The name, "Ray Morrison," itself sounds like a book's hero—in fact, I prefer it over "Frank Merriwell" or "Fred Fearnot."*
>
> *You picture him in college as the honor student, the athlete hero, and the clean-living Christian university admired and respected. The funny part about it is that Ray Morrison was just that—or those—in his undergraduate days at Vanderbilt. Even if he tried, it would be hard to keep anyone from respecting him. It's automatic. He inspires confidence, reflects sincerity. And every minute he's himself without the sign of pose. I list that among his finest qualities.*

In Morrison's five seasons at Vanderbilt, his yearly records include 7-3, 3-5-1, 7-2, 6-3 and 2-7-1. In 1937, his Commodore crew was involved in two plays that became a part of Southeastern Conference football history. Against LSU in Nashville, Commodore tackle Greer Ricketson ran for a fifty-yard touchdown on a "hidden ball" play for a 7–6 victory.

In the last game at Dudley Field against Alabama, Vanderbilt's Carl Hinkle narrowly missed blocking a Bama twenty-three-yard field goal

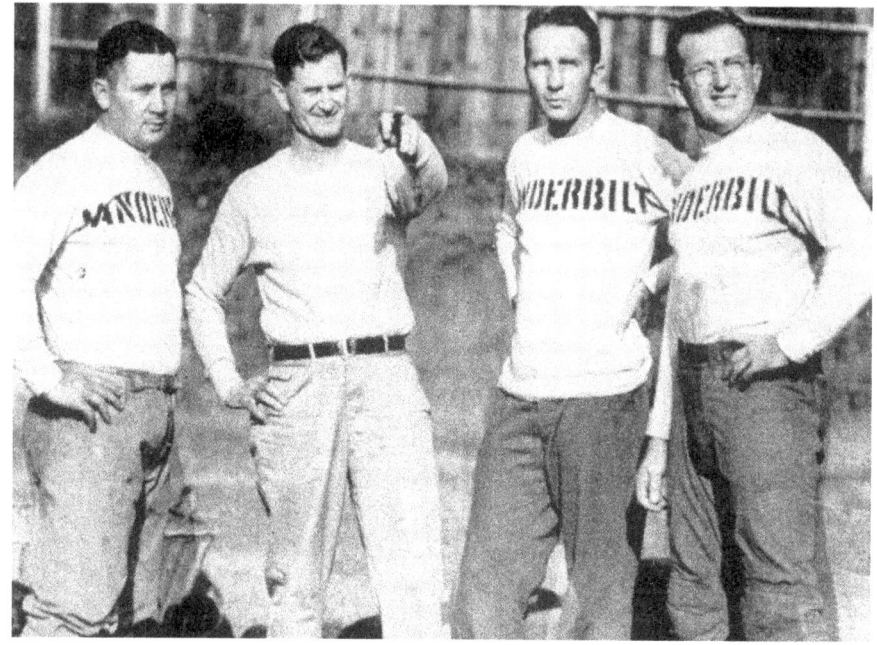

Ray Morrison succeeded Dan McGugin in 1935. Part of Morrison's coaching staff (left to right) included Henry Frnka, Coach Morrison, Russell McIntosh and J.C. Wetsel. *Courtesy of Vanderbilt Athletic Communications.*

attempt that was good and gave the Tide a 9–7 win. It was not known at the time, but the winner of the game was to be given an invitation to the Rose Bowl. This would have been Vanderbilt's first bowl bid. Morrison was rewarded with the SEC's Coach of the Year honor in 1937.

Including the 1918 season, Morrison's overall record at Vanderbilt was 29-22-2 in six seasons. Morrison resigned after the 1939 season with a 2-7 record. He finished his college coaching career at Temple (1940–48) with a 31-38-9 record and at Austin College (1949–51). Morrison's overall coaching record was 143-108-27.

Morrison returned to SMU after his coaching career ended to become vice-president of development for eleven years. He died in Miami Springs, Florida, on November 19, 1982, at age ninety-seven. His body was cremated.

Morrison was selected to the National College Hall of Fame in 1954 and the Tennessee Sports Hall of Fame in 1970. During one of his numerous homecoming trips to the Vanderbilt campus, Morrison was asked to tell of his most cherished moment in football. His reply: "When I was chosen to succeed Coach McGugin at Vanderbilt."

Ty Cobb Practices as Vanderbilt Football Player

The great and controversial Ty Cobb came to Nashville during Thanksgiving week of the 1911 Vanderbilt versus Sewanee football game. Cobb was not in town to give an exhibition on baseball but rather came to Nashville to act.

Cobb was coming off an American League MVP season during which he batted .420. In this off-season, Cobb was performing in the lead role of the play *The College Widow*. The play was held in Nashville's Vendome Theater, which was located on Church Street. Cobb was appearing Monday, Tuesday and Wednesday nights, with a Wednesday matinee.

The *Nashville Banner* wrote about Cobb's Nashville arrival:

> Tyrus Raymond Cobb, the greatest baseball player the world has ever seen, who appears in "The College Widow" at the Vendome for three nights beginning tonight, is the guest of Nashville today and was given the royal reception by the people of the city.
>
> Arriving this morning from Atlanta he rested at the Duncan Hotel for a few hours and after dinner was taken out for an automobile ride by Messer's W.G. Hirsig and Bill Schwartz and Charles Davis in the car of Mr. Joe Holman, who is himself a great baseball fan.
>
> On the stage Mr. Cobb is maintaining the same high average that has marked his work on the diamond. Although the footlights are new to him, he declares he never had stage fright and likes the work.

Vanderbilt Football

> *"Much to the surprise of everyone, and myself in particular, I managed to get through the first night without that awful bugaboo stage fright attacking my heart and dropping me in my tracks," said the great Tyrus this morning in his room as he reclined on the bed with a black cigar between his lips.*

Cobb visited the Monday practice of the Vanderbilt football team and met with Coach Dan McGugin and all of the players. Most of the team members attended Cobb's Monday night performance.

The next day, Cobb, who was twenty-five years old, returned to the Vanderbilt campus and was more than a spectator at practice. Cobb traded in his Detroit Tigers baseball uniform for a Commodore football uniform and practiced with the team. The football practices and games were held on the original Dudley Field.

Spick Hall, writer for the *Tennessean*, wrote about Cobb's transition from the diamond to the gridiron:

> *Tyrus Cobb Dons the Moleskin Out on Dudley Field*
> *Premier Ball Player Joins With Vanderbilt in Practice*
>
> *Not content with being the hero of Atwater, and wanting something a little more substantial along football lines. Tyrus Raymond Cobb, the greatest batsman in the world today, donned a Vanderbilt uniform yesterday afternoon and practiced all afternoon with the Commodores. Ty has never played college football, but it was evident that the game appealed to him. Football naturally appeals to any great athlete, no matter in what branch of athletics he happens to be proficient, and Ty is no exception to that rule.*
>
> *Those who know the story of "The College Widow," in which Ty is taking the leading role at the Vendome, know that he captivates his schoolmates and his "Liebachen" by making a run for 105 yards, after the manner of the much talked of Sam White of Princeton. Well, Ty, after seeing Vanderbilt at work on Dudley Field Monday, decided that he would like to try it for himself; so he did.*
>
> *As the Commodores did not have a scrimmage, Cobb was not called upon to do any of the rough work, but what there was to do he jumped right in and began trying with the others. Drop kicking and punting, forward passing and catching the punts, were the main features of the afternoon work for Vanderbilt; hence they were the stunts which Tyrus did. Ty could*

be developed into a great kicker—there is no doubt about that. Naturally, most people think that we are trying to make Ty do something that he really can't, but without any previous personal knowledge of how to kick.

Ty punted the ball yesterday as far as fifty yards in the face of a brisk breeze. His boots were, as a rule not spirally inclined, but just as straight walloping he booted the oval all over the lot, just as he is wont to slab the pill in the summer time. After Dan McGugin had given Ty a few lessons in punting, he was able to get off a number of long spirals which Hardage, Robins and Kent Morrison had considerable difficulty in handling.

At dropkicking Cobb also showed that he could readily pick up the coveted knack. He dropped several over from the 35-yard line at an angle, and incidentally it might be mentioned that the field was a sea of mud and the ball was well soaked.

Cobb weighs nearly 180 pounds when he is in condition and now he is off about three or four pounds. He looks, however, as though he were a slender youth, so well is he put together. He has a perfect build for a halfback, with his broad shoulders, thick chest and speedy pins. After practice was over yesterday Ty had a race with several of the fastest Commodores and put them all to rout. Ty said he would certainly like to play football with this bunch just for one season.

Cobb was unable to remain in town for the Sewanee game, but as the Sewanee players arrived in town, many watched the Wednesday night performance of his play. Cobb was portraying the lead as Billy Bolton. The *Tennessean* described *The College Widow*, written by George Ade:

> George Ade has made of the girl athlete, a type of character too little known on the stage today. With that touch which has made him celebrated as a student of character types the great Hoosier playwright has put before us a girl of snap and vigor and a knowledge of sports that men will travel far to see her. While the athletic girl is one of most pleasing characters developed in the production she is just one of the scores of everyday characters which have been so carefully evolved in the action of the play, types which we all recognize at first glance.

The Vendome was built in Nashville as an opera and playhouse with a pair of balconies and sixteen boxes. The first performance was in 1887.

The venue provided vaudeville acts and movies in the 1920s. The balconies caught fire in 1967, virtually destroying the building. The following year, the building was demolished and became the Lowe's Vendome Theatre.

Cobb traveled the South, Midwest and eastern seaboard during that winter of 1911–12 performing with the acting troupe of *The College Widow*. Cobb also starred in a 1917 silent film, *Somewhere in Georgia* based on a short story by Grantland Rice. This plot was about a Georgian bank clerk forced to leave his sweetheart when he leaves for Detroit to play baseball. The hero, Cobb, returns to Georgia for an exhibition game, is kidnapped, beat ups his abductors and arrives in time to win the baseball game.

The Georgia Peach was credited with breaking ninety baseball records during his twenty-four-year career. Cobb owns the highest major league batting average (.367) and the most career batting titles (11) and was the top player with hits (4,191) until Pete Rose passed him in 1985.

Cobb played baseball with Detroit (1905–26) and the Philadelphia A's (1927–28). He gained a reputation as an arrogant, hard-nosed player with a confrontational personality. Cobb was an inaugural member of the Baseball Hall of Fame in 1936 and died in 1961 at age seventy-four.

Vanderbilt might have been inspired by Cobb's visits to the campus, as the Commodores crushed their rivals from the mountain, 31–0. In later years, Cobb admitted that he was not an actor, but for one autumn day in 1911 he was a Vanderbilt Commodore football player.

VANDERBILT SMASHES BETHEL 105–0

If you scan the Vanderbilt football records, you will find that the Commodores beat Bethel 105–0 for the most points in a game. The game was played on September 28, 1912, on the original Dudley Field. Coach Dan McGugin's club played most of the game during a downpour of rain, with the field turning into mud.

The *Tennessean* gave this report:

> *A waterlogged pasture was the enraging spectacle which presented itself to the eyes of those brave enough to drill out to Dudley field yesterday afternoon, where incidentally, Vanderbilt amassed 105 points to Bethel's nothing. That is the largest score, if the records are correct, ever made by an athletic team of Vanderbilt. Once in the long ago, the Commodores scored 98 points against the University of Nashville and later, they with the count to 104 points against Central of Kentucky.*
>
> *Naturally, it makes the Commodores look pretty good on paper to say that they opened the season by breaking a record with only two week's practice, much of which was done in very hot weather and before a number of the varsity men had arrived. Nevertheless, it was not a great victory. Bethel was lamentably weak on defense on the offense they did come within hailing distance of a first down. But for all that, some of those Bethel men, notably Captain Cody, played gritty football. Their main trouble was lack of unity in action. They were not well trained along football lines, although physically, they seemed never to be in distress.*

Vanderbilt Football

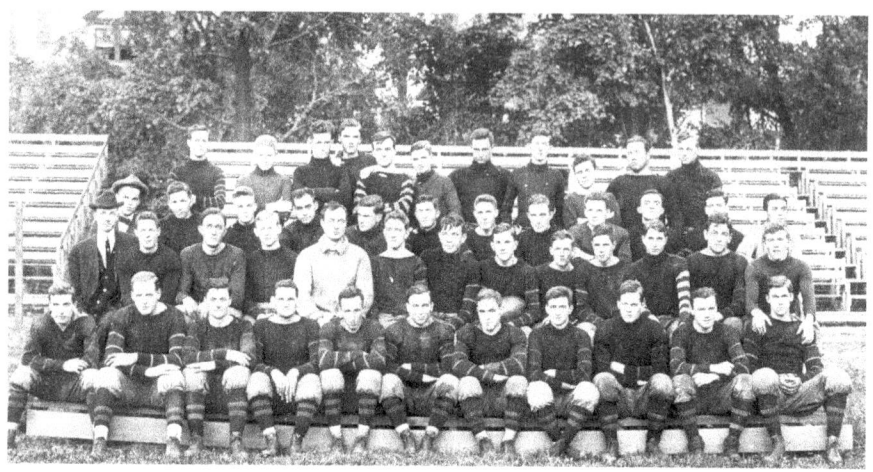

The 1912 Vanderbilt football team was the highest-scoring college team in the nation. In their first game of the season, the Commodores blasted Bethel College, 105–0, for the most points scored in a game. *Courtesy of Vanderbilt Athletic Communications.*

After stopping Bethel on the opening drive, the Commodores lined up to receive the punt. Vanderbilt's Wilson Collins took the punted ball and ran to his far right for a forty-five-yard touchdown to begin the barrage of points. Bethel's offense failed to move the ball and was forced to punt again. Collins once again received the ball and tore through the Bethel defenders for his second touchdown.

The *Tennessean* continued:

> *After that terrible opening assault, it was apparent that the only interest in the game would be the work of the new men and the amount of score heaped up. Though the ball was wet, muddy, and hard to handle, the Commodores worked a host of forward passes which bewildered the Bethel players nearly out of their wits. They did not seem to know what to do when they had the chance, for on three different occasions, Vanderbilt's forward passes went directly into the hands of Bethel players and each time, the men merely slapped it to the ground instead of catching it.*
>
> *Soon after Vanderbilt had made twenty odd points, McGugin began to yank his regulars out of the line-up. He used substitutes during the greater part of the game and as usual, the subs did as well as the regulars, mainly, of course, the thing had been started and all they had to do was run, the fray had been won in the first few minutes.*

Tales of Commodore Gridiron History

Zach Curlin was the starting quarterback for Vanderbilt, but his backup, Rabbi Robbins, played well in the muddy environment. A newspaper report stated that Robbins, the mud-horse, "received a kick-off on his own 30-yard line and by skating, side-stepping and dodging managed to elude the whole Bethel team, making the entire distance of seventy yards to the goal line."

Also, it was suggested that all the Commodores had to do to churn out big chunks of yardage was to simply call a play. Accolades were given to Commodore reserve players George Reyer, Herman Daves and Yunk Chester for their outstanding play.

Daves was credited with his blocking and tackling skills by throwing Bethel running backs for losses and opening holes on the offensive line. Reyer received his notice by going through the Bethel offensive line three times in succession and sacking the quarterback before he was able to release a pass. Reyer, playing in the halfback position, threw a forty-yard touchdown pass and another toss for twenty-five yards.

The *Tennessean* did notice the sportsmanship of the Bethel players:

> *Captain Cody, left tackle for the Bethel team, was about eight hundred per cent above the average of his teammates. He is a real football player and if he had been working on a strong team instead of one which was being run over at will, he would have done some tearing up.*
>
> *There was one thing to be said of the entire Bethel team—they all gave the best they had. They are not a bunch of quitters and though the score was ridiculously large, they took their defeat like sportsmen and fought to the best of their knowledge and ability.*

The final score of 105–0 could have been worse. Quarters were nine minutes long, but through an agreement by both teams, the final two quarters were reduced to seven minutes each. For Vanderbilt, Collins scored five touchdowns; Lewie Hardage, two; Robbins, two; Enoch Brown, three; Reyer, one; Morrison, two; and Chester, one. The sixteen touchdowns and nine conversions totaled 105 points.

In the next three Vanderbilt games they beat Maryville (100–3), Rose Polytechnic (54–0) and Georgia (40–0). They finished the season 8-1-1 with a loss to Harvard and a tie with Auburn. The 1912 Commodores outscored their opponents 391–18.

The Commodores' 1915 Point-a-Minute Team

The outlook for the upcoming 1915 Vanderbilt football season was bleak. The Commodores were coming off a losing record of 2-8, the first under Head Coach Dan McGugin and second in the school's twenty-five years of playing football.

Adding to this bleakness was the fact that Vanderbilt returned ten experienced players from the previous year, which meant that inexperienced freshmen would be a key to the team's success. And success they did have.

McGugin built his 1915 squad around brilliant 130-pound junior quarterback Irby "Rabbit" Curry. In the line was Josh Cody, a two-way sophomore tackle who was a fierce tackler and dominating blocker. Vanderbilt was a member of the Southern Intercollegiate Athletic Association and facing a ten-game schedule.

The Commodores established a team record that season not equaled today. They scored a grand total of 514 points in 510 minutes of actual playing time, thus ranking them as a legitimate "point-a-minute" team. Vanderbilt averaged 51 points a game.

Vanderbilt racked up 459 points before being scored upon. The team recorded seven shutouts to open the season. These victories include Tennessee Normal (MTSU), 51-0; Southwestern, 47-0; Georgetown, 75-0; Cumberland, 60-0; Henderson-Brown 100-0; Mississippi, 91-0; and Tennessee, 35-0.

The Vols were the first real test for the Commodores and came to Nashville as the SIAA defending champions, loaded with confidence.

Tales of Commodore Gridiron History

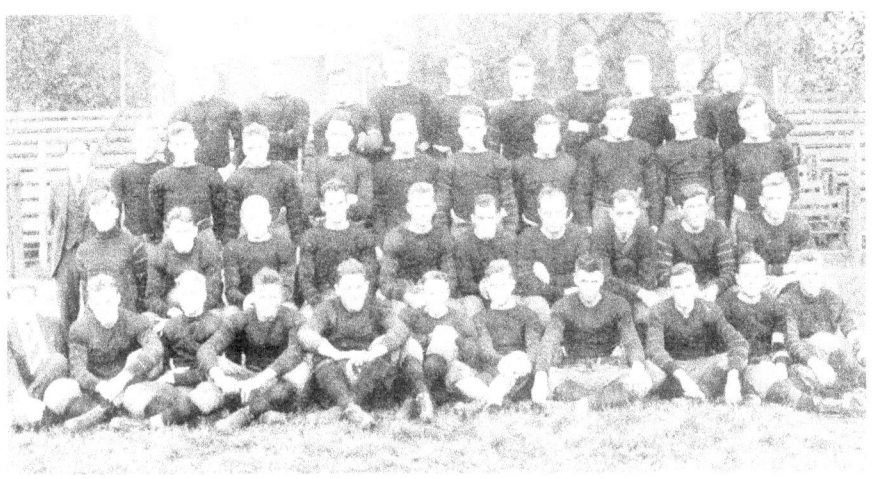

The 1915 Vanderbilt football team scored 514 points in 510 minutes of play to become the only point-a-minute team in the school's history. *Courtesy of Vanderbilt Athletic Communications.*

In the book by Fred Russell and Maxwell Benson *Fifty Years of Vanderbilt Football*, the Vols' defeat is given this summary:

> They were swamped, 35–0 as Curry and Bob Turner ran wild. The Rabbit got away for 50 yards the only touchdown of the first half. In the third quarter, Johnny Floyd ripped off 47 yards and Hubert Wiggs took it over.
>
> Then Turner entered the game and his first run was 35 yards to the six-yard line, where Wiggs again scored. The next time he sprinted 60 yards himself for the "touch" and the last score came on a 20-yard dash by "Cutter" Northcutt, Curry's substitute. The victory was beclouded by a most unfortunate spine injury to Bennett Jared, who died a few months later.

The Tennessee game placed the Commodores at 7-0 and unscored on until the next week. A trip to Charlottesville, Virginia, to face the University of Virginia was next on the schedule. The high-flying Commodores were overwhelmed, 35–10, by the Cavilers. Curry ran for eighty yards and scored a touchdown on a fumbled punt. Cody booted a twenty-yard field goal for the only other score for the Commodores. Vanderbilt could only manage five first downs in the contest.

Next was the Auburn game, which McGugin had been pointing to since before the season. The game was played in Birmingham on Rickwood Field

(built in 1910), which still exists today and has been certified as the oldest ballpark in America. It was home to the Birmingham Red Barons of the old Southern Association for decades until 1987.

Vanderbilt jumped out to a 17–0 lead on a rain-soaked field. A Curry pass to captain Russell Cohen opened the scoring with the PAT. Cody personally took over from that point. Described in *Fifty Years of Vanderbilt Football*:

> *In one of the greatest exhibitions of punt covering ever seen, he* [Cody] *smothered the receiver every time, recovering two fumbles, one across the goal line for a touchdown. Then, in the last ten seconds of play, Cody dropped kicked a three-pointer from the 33-yard line. Zerfoss and Friel punted splendidly. Curry's generalship was superb, and late in the game the Gold and Black line rose as one to throw back three Auburn charges on the five-yard line.*

The final game of the season for the 8-1 Commodores was on Thanksgiving Day in Nashville against rival Sewanee. At stake entering the game was the SIAA championship. A shutout over the "Men From the Mountain" would complete the SIAA schedule of being unscored on.

Fifty Years of Vanderbilt Football describes the season finale:

> *What a thriller it was! Thoroughly outplayed the first two quarters as Capt. Dobbins and Hek Clark led the Tiger attack, intermission found the Commodores behind 3–0 due to "Red" Herring's field goal from the 20-yard line. Dan McGugin took the boys over by Engineering Hall for a little talk.*
>
> *They came back flaming, but the start of the fourth quarter saw the score still 3–0. Then a sustained drive got underway that ended with "Dough" Ray plunging touchdownward from the four-yard line. That pulled the stopper out of the bottle. Lipscomb and Cody blocked a punt and Pud Reyer recovered on the five-yard line. Again Ray went over. Zerfoss skirted end for 26, Curry followed with a 34-yard dash and a third touchdown.*
>
> *Little Rabbit was battered and bruised from terrible pounding, but he generated enough steam for the top run of the day, 80 yards for a touchdown with Josh Cody clearing his path, then limped to the bench amid the most tumultuous demonstration ever given a Commodore hero. The final count, 28–3, and another SIAA championship.*

Tales of Commodore Gridiron History

During the season, Curry accounted for 118 of Vanderbilt's season total of 514 points. Seven out of eight newspapers voted the SIAA championship to the Commodores. The *Atlanta Constitution* declared it a tie between Vanderbilt and Georgia Tech. Curry (unanimously), Cohen and Cody were named all-Southern.

In 1975, the team's manager, James G. Stahlman of Nashville, hosted a sixtieth reunion for the weekend of the Georgia game. Stahlman was a member of the Vanderbilt Board of Trustes and longtime supporter of Vanderbilt athletics. Of the twenty-one lettermen from that 1915 team, eight were still living and seven were present at the reunion.

Attending the reunion were Russell Cohen, Henry K. Ray, Hubert Wiggs, Kent Morrison, Alfred Adams and Dr. Tom Zerfoss. Dr. George Reyer of El Paso, Texas, could not attend due to an illness. Rabbit Curry had died in World War I during an airplane dogfight over Chateau Thierry. He was buried in his home state of Texas.

The group attended a pregame luncheon at the Belle Meade Country Club and gathered at the Vanderbilt-Georgia game to be recognized at halftime. Fred Pancoast's 1975 Commodores lost to Georgia that day, 47–3, but ended the season with a 7-4 record. Sometime while on the Vanderbilt campus, the aged athletes strolled over to the Engineering Hall to locate the spot where they stood recalling McGugin's halftime talk with Sewanee.

John Bibb of the *Tennessean*, in reporting on the 1975 reunion, wrote about Stahlman:

> *This same 1915 team was heading for Memphis to face Ole Miss. The team was undefeated [5-0] and unscored on. Somewhere near Dickson, Tennessee, the Commodores' train was halted and forced to sit for hours while crews worked to clear a freight train wrecked ahead on the tracks.*
>
> *As student manager, part of Stahlman's duties was to attend the various needs of the individual players. As the day wore on, it became apparent the Commodore players faced the distinct possibility of no lunch. The dedicated Stahlman, departing the idled train made a forage into neighboring orchards and returned with pocketful of apples—noticeably green, but to the hungry football players, quite delicious. The next afternoon, Vanderbilt's quick-stepping Commodores, hurried past Ole Miss, 91–0.*

IRBY "RABBIT" CURRY INSPIRED VANDERBILT

Irby "Rabbit" Curry was an all-American quarterback for Vanderbilt in 1916. The brilliant runner was born in Marlin, Texas, in 1894 and was a product of Marlin High School. After graduating from Vanderbilt, Curry volunteered for service during World War I. After completing his Ground School work he was ordered to Rantoul, Illinois, to the Flying School.

Heroically, Curry was shot down over France near Chateau Thierry and was killed during aerial combat on August 18, 1918. The death of Curry stunned Vanderbilt coach Dan McGugin and the Vanderbilt family. The image of Curry had been with McGugin since the former quarterback made an impression with his heart and not his size.

Vanderbilt was scheduled to play the University of Texas, in Dallas, on October 22, 1921. The Commodores were heavy underdogs, and during McGugin's pregame talk, Curry was on the coach's mind. *Fifty Years of Vanderbilt Football* by Russell and Benson reveals the McGugin's motivational speech:

> *You are about to be put to an ordeal which will show the stuff that's in you! What a glorious chance you have! Every one of you is going to fix his status for all time in the minds and hearts of his teammates today. How you fight is what you will be remembered by. If any shirk, the Lord pity him. He will be degraded in the hearts of the rest as long as they live.*
>
> *Man is a curious kind of a "critter." You will all doubtless eat and have comforts and "butt around" for a good many days, but during the next hour*

Tales of Commodore Gridiron History

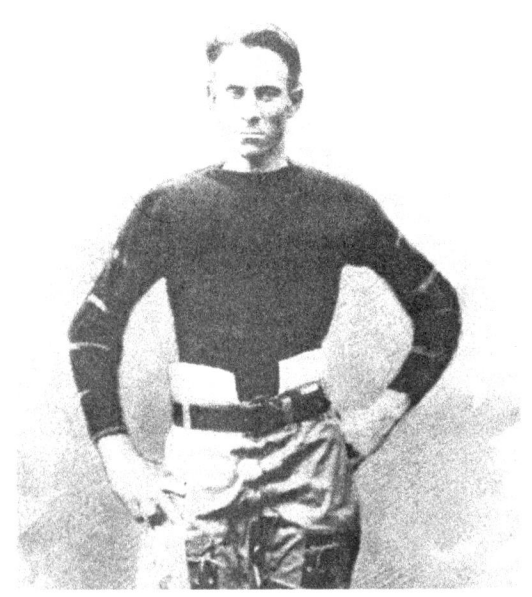

Irby "Rabbit" Curry was a Third Team all-American and all-Southern quarterback for Vanderbilt in 1916. He was killed during World War I. *Courtesy of Vanderbilt Athletic Communications.*

you must forget yourselves absolutely. You are to hurl yourselves like demons with the fury of hell on the crowd that has come here to humiliate us. The man worthwhile is the man who can rise away above and beyond himself in the face of a great task.

I am glad Mr. Curry is here. Some of you knew Rabbit. We felt toward him the tenderness a mother feels towards her own little boy. He had a little slender body; he weighed only 128 pounds, but he had a heart as big as that loving cup over there on the mantel. He was modest; his life was absolutely clean; and what a fighter he was. His life was a great contribution to Vanderbilt—traditionally to our athletic traditions. The influence of his spirit will always abide. He always wanted to play with Vanderbilt against Texas. His body is resting only a few miles south of here; but his spirit is hovering above us now. Some of these days I want to see his likeness looking down on our athletic fields. I am glad his father is here so that he can see face to face, how we regard his son.

There is one thing that makes me sick at heart. I heard repeatedly before we left Nashville that this Vanderbilt team, this crowd of men into whose faces I now look, might win from Texas if it would only fight. Has anybody the right to imply such an insult? And, if so, when before now could such

a thing be said of men from Tennessee? How about Pickett's men who moved out of the wood and exposed their breasts and faces to be shattered and torn as they moved up that slope? And how about the Tennesseans of the Thirtieth Division, who broke the Hindenburg line—a task even greater because it was accompanied by so much mud and misery. All but a few here are Tennesseans and the rest have elected to be educated here. You are a part of us and you must uphold the traditions of Vanderbilt and Tennessee.

Who in the devil started all of this bunk about the Texas team? Who thinks they are unbeatable? They say that they have the greatest team in their history and, perhaps this is true. They say Vanderbilt never had a team which could defeat theirs of this year, and that is not true. Texas has no shield like ours. We have some scars on it, but there are a lot of stars there, too. Texas has no such athletic tradition and history.

They say the climate is against us. That is not true. The change should do us good. This light, pure air will help us.

Sports writer Blinky Horn covered the game for the *Tennessean* and wrote about this about the Commodores 20–0 victory:

Vandy outcharged, outfought and outgamed the boastful Texans. Their courage was finer. Their stamina was greater. Thrust into the throes of a Turkish bath day which blistered tongues and made legs weary the McGuginites shook off the galling heat and won a hellish battle on a hellish afternoon.

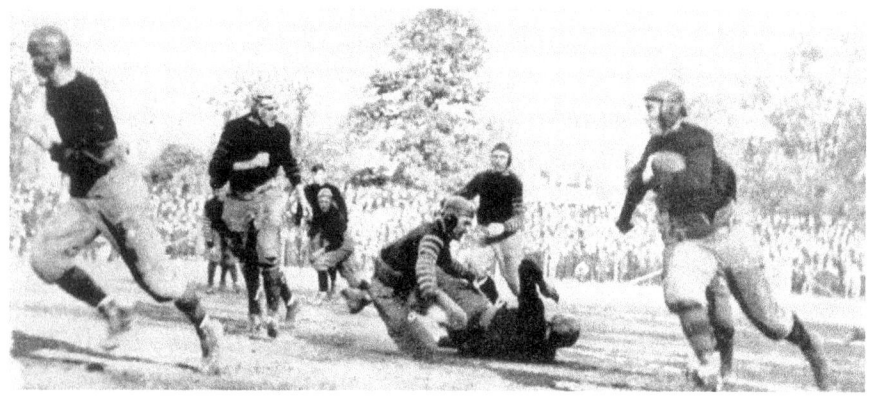

Rabbit Curry (with ball) makes one of his brilliant runs against Tennessee in 1915 on the original Dudley Field. *Courtesy of Vanderbilt Athletic Communications.*

Tales of Commodore Gridiron History

> *The spirit of Rabbit Curry, Commodore immortal who sleeps but a scant 150 miles away from Dallas, hoisted the McGuginites upon a fighting pinnacle only reached by the gods when they quarrel.*
>
> *With his father huddled on a Vandy bench, his face a silent but beseeching plea for stiffen of the arrogance of Texas, the Commodores responded with a moleskin exhibition rarely surpassed in all their long and Gem-like history. The victory surely must make the gallant Curry rest with more repose in his Texas tomb, now wreathed with the hale of a Commodore conquest.*

Curry had been the captain of the football team, had played baseball and had been a member of the track team. Lieutenant Hunnicutt, who flew with Rabbit, described First Lieutenant Curry's death in a letter to his family:

> *Irby and a classmate from Vanderbilt were in the same aero squadron. At Chateau Thierry their squad engaged the Richthoffen's circus (Germany's greatest aero squad). Irby was wounded and went into a tight spiral and to land. He never gained strength to come out of the spiral and crashed to the earth. His classmate downed a plane and landed to get the German, but landed on German soil and was captured. Nine out of eighteen of Irby's squad were killed. The Germans suffered greater than the Americans.*

After learning about the death of Curry, McGugin wired this telegram to the *Tennessean*:

> *During the four years of my intimate association with Irby Curry, I never heard him utter a word his mother might not hear and approve. A game sportsman and scholar, truly he was gentle as a dove. He had a lion's heart, and now a hero's death. Poor Little Rabbit! How he pulls at the heart-strings of all of us who knew him and therefore honored and loved him tenderly.*

McGugin would have a photo of Curry hanging prominently in his office until his death in 1936. Curry is buried in his hometown of Marlin, Texas.

THE VANDERBILT AND VOLS CONFLICT OF 1918

The date was November 9, 1918. One great conflict had just been resolved and another one began.

The day before, Germany had agreed to the surrender terms dictated by President Woodrow Wilson to end World War I (the armistice became effective on November 11). But the conflict that began that day continues through 2011 and probably beyond: did Vanderbilt play Tennessee in a football game in 1918? The Commodores say, "Yea," and the Vols say, "Nay"…well, sort of.

According to the 2011 media guides from both universities, Vandy claims to have one additional win (28-71-5) over UT, which shows one less defeat with the Commodores (72-27-5). The discrepancy is a game that was played in 1918. Tennessee doesn't include the game as official.

The Vols media guide notes that during the World War I years of 1917 and 1918, the Tennessee Athletic Council officially suspended varsity football. This was necessary since Vols coach John Bender was enlisted in the military as an instructor in South Carolina and because the majority of his players were called into military service.

During this two-year period without varsity football, two unofficial teams were formed from army recruits and students. One of these unofficial teams representing the University of Tennessee was the Student Army Training Corps, which came to play in Nashville in 1918. From 1892, the year the rivalry began, through 1916, Vanderbilt held a 12-2-1 advantage over "that school from the East."

Tales of Commodore Gridiron History

There certainly was a game played that autumn afternoon on Vanderbilt's original Dudley Field. According to the *Nashville Tennessean* and the *Nashville American*, the game was to benefit the United War Work Fund. Reserved seats were one dollar.

The rivalry was just as emotional in those days, as the newspaper gave this account: "When the Tennessee clan comes down from the eastern mountains and comes to Dudley Field around 2:30 o'clock today, the Commodores will have quite a little argument to settle with them. It dates back to the fall of 1916, when the Vol eleven surprised Vandy with a 10–6 defeat and then crawled into their hole for two years gloating over their accomplishment. Yes, the Black and Gold must be vindicated today."

Vanderbilt did win the gridiron contest by a whopping 74–0 rout (both media guides report 76–0), and the Vols were always referred to as the University of Tennessee and not Student Army Training Corps. The Commodore coach, Dan McGugin, was on leave for army duty, leaving future Vanderbilt head coach Ray Morrison as the interim head coach.

Sports writer Cicero Slack of the *Tennessean* wrote: "Crumbling the University of Tennessee eleven like to a page of tissue in the mailed fist of a giant, the Commodores yesterday out on Dudley Field walked over their prostrate foe to a 74–0 victory and gained sweet revenge for the 1916 defeat."

In order to be fair, the *Journal and Tribune* in

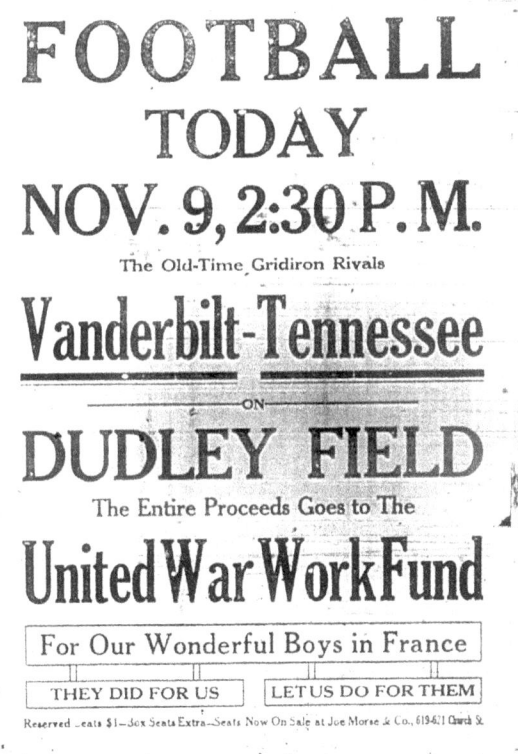

A promotional advertisement in the *Nashville Tennessean* for the 1918 Vanderbilt versus Tennessee game. *Courtesy of the author.*

Knoxville reported before the game: "It is expected that the Orange and White players will give a good account of themselves in the game today, when the S.A.T.C. eleven goes against Vanderbilt, at Nashville." This is a clear reference to the football team representing UT as the Student Army Training Corps.

The *Journal and Tribune* reported on the game's results: "Against the University of Tennessee weak resistance, the Vanderbilt football eleven today ran rampant and piled up a score of 74–0. Berryhill, the sensational Vanderbilt back, had one of the greatest days of his football career accounting for six of the eleven's dozen touchdowns against the Knoxville clan."

Vanderbilt's Grailey Berryhill's six touchdowns are not in the Vanderbilt record book, probably because this would not be considered the modern era. Frank Mordica's five touchdowns in 1978 are listed as the Vanderbilt record for most touchdowns in a single game.

An authority on Vanderbilt football history would be the late *Nashville Banner* sportswriter Fred Russell. In *Fifty Years of Vanderbilt Football*, published in 1938, he wrote about the 1918 Vanderbilt/Tennessee football game: "Salient after salient was wiped out by Gen. Morrison's forces and Tennessee's reinforcements could not check the tide. The retreat turned into a bloody, hopeless rout. Berryhill was cited for bravery for his wonderful outflanking the enemy, by which he took six positions [touchdowns] single-handedly. The result was 76–0." Russell doesn't mention any conflicts and recorded the game in his book as a victory for the Commodores.

Unlike Vanderbilt, none of the Volunteer players from that season appears on their all-time roster. The Tennessee football media guide does not name an interim coach for the Vols. The name of the second Vols' football team that represented the university in 1918 was the "Fighting Mechanics." The team's results are not listed.

The week before the Vanderbilt game, this "phantom" Tennessee team opened the season with a loss to Sewanee by a similar score of 68–0. This Tennessee squad finished the season at 3-2 with wins over Maryville (9–7), Milligan (32–0) and Tennessee Military Institute (46–0).

If you are a Vanderbilt fan, you might argue that it should be official, but if you wear the orange you will probably disagree.

JOSH CODY, A TOUGH TWO-WAY PLAYER

Vanderbilt students have been playing football since 1890. In that time, only five former Commodores have been selected to the National College Football Hall of Fame. One of these honored was Josh Cody.

Cody was born in nearby Franklin, Tennessee, and attended Battle Ground Academy. In his first year at Vanderbilt (freshmen were eligible), Cody dropkicked a forty-five-yard field goal against Michigan in just his second game. Playing from his tackle position, he dropped back into the backfield and tossed a twelve-yard touchdown pass to Rabbit Curry against Virginia that same year.

Cody played on the 1914 (2-6), 1915 (9-1) and 1916 (7-1-1) Commodore teams but went on to serve in the army for two years as a lieutenant during World War I. He returned to Vanderbilt in 1919 (5-1-2) to finish his final year of eligibility. The six-foot-two, 230-pounder played both ways—as a tackle who was dominating on defense and as a fierce blocker on offense.

As a multisport player, Cody participated in basketball, baseball and track, earning thirteen letters. He was an all-Southern performer the last three seasons he played. Cody was also selected as an all-American in 1915, 1916 and 1919. The Southeastern Conference was organized in 1932.

Legendary former *Nashville Banner* sports writer and Vanderbilt alumnus (class of 1927) Fred Russell once said about Cody: "When I think of Josh in his college days, I get a mental picture of this great big fellow playing catcher in the spring and between innings running out beyond the outfield to throw

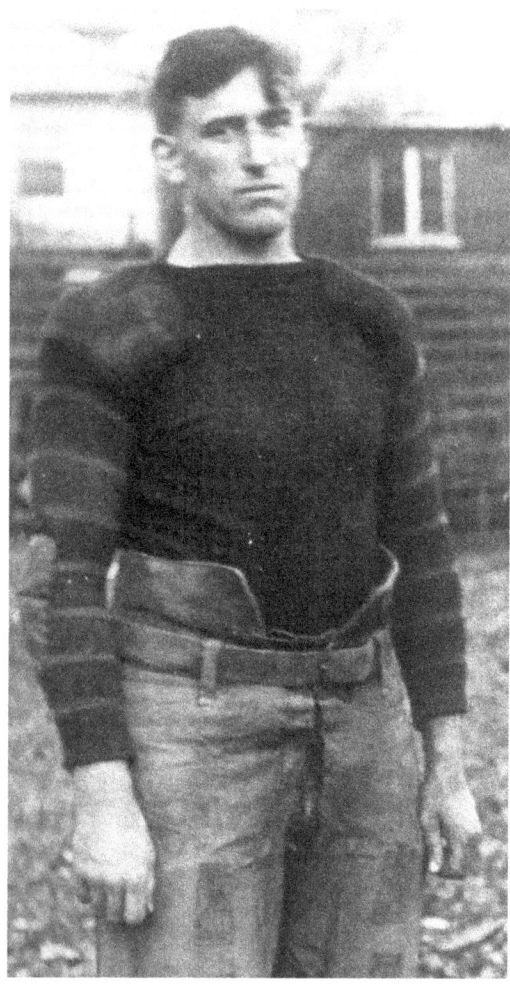

Josh Cody was a punishing blocker and tackler who is the only Commodore to earn all-American honors in three different seasons. *Courtesy of Vanderbilt Athletic Communications.*

the shot or the discuss in his baseball uniform. He was unbelievably skillful and nimble for a big man in basketball, and in football where he's a legend."

A teammate of Cody's in 1919, Ralph McGill, became the publisher of the *Atlanta Constitution* and said about Cody:

> *He was a great big fellow and one of the most seriously dedicated fellows I've ever met. He was a farm boy and he didn't have any polish but he was very honest and sincere. He didn't have scholarship—we had none in those days— but he had a real job. He literally cleaned the gymnasium every day, cleaned up the locker rooms and the showers, and tended to the coal furnace after practice.*

Tales of Commodore Gridiron History

He was a big man, squarely built, quiet, almost shy, and enormously decent. He practiced long hours to place kick and became the team's place kicker. He wasn't fast, but he was fast for a big man. He didn't like to wear pads. He got a hold of an old quilt and sewed it to the shoulders of the jersey and that was all the padding he wore.

Cody began a coaching career at Mercer University in 1920 as coach of all sports and athletic director. He returned to Vanderbilt in 1923 to serve as head basketball, baseball and assistant football coach under his former mentor, Dan McGugin. On the hardwood, Cody's Commodore was 47-50 in four seasons. His 20-4 mark won the 1927 Southern Conference championship.

Cody left Vanderbilt in 1927 to become the head football and basketball coach at Clemson University. It was Cody who gave Red Sanders, a recent Vanderbilt graduate and future Vanderbilt head football coach, his first coaching job as an assistant at Clemson in 1927. In his first year as head football coach at Clemson, he led the Tigers to a 5-3-1 record and back-to-back 8-3 seasons in 1928 and 1929.

The Vanderbilt alumnus was very popular with the students and administration at Clemson. He was 4-0 coaching against rival South Carolina. Due to his success, rumors were circulating that Cody would be leaving for a better head coaching position. Showing its gratitude, the university presented Cody with a new black Buick in May 1929. In his final season at Clemson (1930), the Tigers were 8-2. On the basketball court, his Tigers' record was 48-55 in four seasons.

Going back to Vanderbilt in 1931 was Cody's next stop in his coaching career. He became McGugin's chief assistant and head basketball coach. In his second stint as the Commodore basketball coach, Cody was 51-50. McGugin retired as Vanderbilt's football coach at the end of the 1934 season and was replaced by former Vanderbilt quarterback (1908–11) Ray Morrison. Morrison had been SMU's head football for thirteen seasons, compiling a 84-44-22 record.

Tennessean sports writer Raymond Johnson wrote after Cody's death in 1961:

Josh Cody wanted to be Vanderbilt's football coach so bad that he gave up the head man's job at Clemson College after four successful seasons to return to his alma mater. That was in 1931 when he came back here as Dan McGugin's first lieutenant. Long ago the cherished thought faded.

> *Cody's Clemson teams of 1928-29-30 had won 24 games and lost eight when he happily jumped at the opportunity to return to his alma mater. The head coaching job would be Cody's when Dan stepped down. At least McGugin would recommend him and he did when alumni pressure forced Dan to retire in 1934 after 30 years, during which time he put Vanderbilt on the football map.*
>
> *A group of old grads opposed Cody. Some claimed it was because he had McGugin's approval. Ray Morrison got the job because the alumni wanted a name.*

Morrison did not utilize Cody's abilities, preferring his own coaches from SMU. There was a breach between the two men, and McGugin did help Cody secure another coaching job. McGugin convinced Florida to hire Cody when its head coaching position became open.

Cody would leave the Vanderbilt campus again in 1936 to become the athletics director and head football coach at the University of Florida. While at Florida, Cody was 4-6, 4-7, 4-6-1 and 5-5-1, for a coaching total of 17-24-2.

In 1940, Cody was on the move again, this time as the line coach at Temple under now head football coach Ray Morrison. The animosity between the two disappeared when Morrison was relived of his Commodore coaching assignment after the 1939 season and record of 29-22-2. Morrison was Temple's head coach from 1940 to 1948. Cody was appointed head basketball coach in 1942 (through 1952) and held this position until he was named Temple's athletics director in 1952.

When the Temple football coach suddenly resigned, Cody went back to the sidelines in 1955 for an encore as his replacement. That team was a dismal 0-8 in his final season as a coach. In his tenure as the Temple's basketball coach, Cody was 124-103 and, in 1944, took the Owls to their first NCAA National Tournament appearance reaching the Elite Eight.

Temple had black players on its basketball teams, and before their appearance in the 1957 NCAA Tournament in Charlotte, segregation was a concern. When asked about the possibility of Temple's team not being allowed in restaurants or hotels, Cody, as AD, responded, "If our team can't go together, we won't go." They stayed together.

Tommy Henderson was a Vanderbilt quarterback and basketball player at Vanderbilt from 1930 to 1932. In tribute, Henderson said after learning of Cody's death: "Josh was one of my closet friends until he went to Temple.

Tales of Commodore Gridiron History

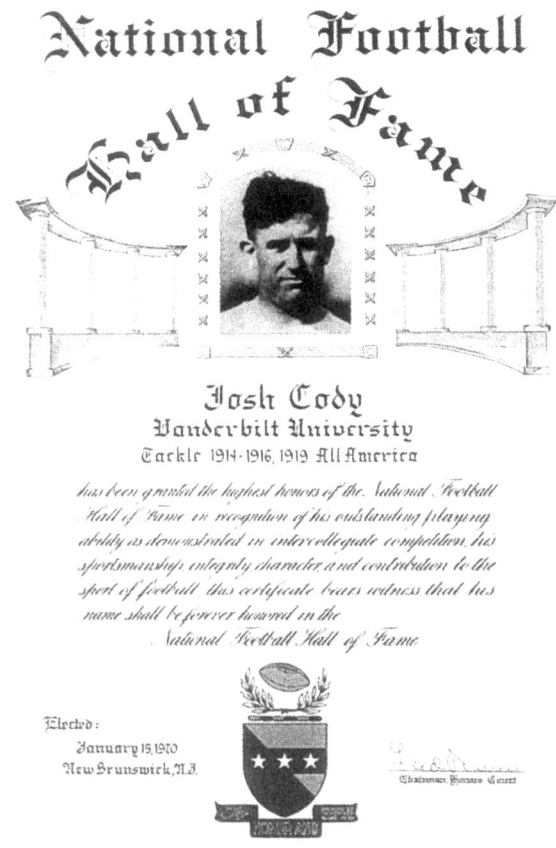

Josh Cody became an assistant football coach at Vanderbilt and head coach in basketball for the Commodores, and he was inducted into the College Football Hall of Fame. *Courtesy of Vanderbilt Athletic Communications.*

After that I'm afraid we lost contact. He had a lasting influence on the men who played for him He was kind and considerate but demanding, too. He was a fine defensive basketball coach who believed in aggressive defensive fundamentals. In football he was respected for what he knew and what he could do with his material."

In 1959, Cody retired to his 190-acre farm across the Delaware River in Moorestown, New Jersey. He died on his farm in 1961 at age sixty-nine. Cody was enshrined into the National College Hall of Fame in 1970 and the Tennessee Sports Hall of Fame in 1999. He is Vanderbilt's only three-time (1915, 1916 and 1919) all-American football player.

Fred Russell told one well-known story about Cody in a chicken-eating contest from his days at Clemson: "When he was at Clemson, he had a

contest with Herman Stegeman, the coach at Georgia. Josh weighed about 260 then. He outstripped Stegeman by eleven chickens. He wasn't satisfied just to win. He just went on to a decisive victory."

Said Cody about the eating contest, "I got two chickens ahead of him early and just coasted."

Dudley Field Is Dedicated in 1922

The Castner Knott Dry Goods Company in downtown Nashville was having a huge sale for a special event. For the women, "Grovers two-strap slippers were on sale at $4.65. Coats of Marvella, Gerche, Tarquina, Marleen, Mousayne, Veldeen, with rich trimmings of fox, squirrel, caracut, beaver, seal, monkey and wolf, from an exceedingly exquisite group" were also on sale.

"They are fashioned along the new popular long lines, emphasizing individual touches in every model. A most remarkable selection at—$105.00," read the advertisements from the *Tennessean*.

The gents were not excluded as Joseph Frank & Son, in its economy annex, were selling "suits with two pairs of pants" at an unusual value of $27.50. The Fulwirth suit with the extra pants practically doubled the life of your suit, stated the special advertisement.

The celebration was for "Stadium Day," the inaugural football game in Vanderbilt's new stadium on Dudley Field on October 14, 1922. The game between Vanderbilt and Michigan drew a carnival-like atmosphere.

Dignitaries and politicians were invited to participate at Dudley Field, the largest football-only stadium in the South at that time. The guest of honor for the dedication game was Cornelius Vanderbilt, the great-great-grandson of the university's namesake.

Accompanied by his wife, Vanderbilt arrived at Nashville's Union Station on the morning of the game, his first trip to the city. The day's first event

Members of the Vanderbilt and Michigan football teams gather with Vanderbilt University dignitaries to dedicate Dudley Field on October 10, 1922. *Courtesy of Vanderbilt Athletic Communications.*

was a luncheon for the young Vanderbilt couple, which was held at the Hermitage Hotel and hosted by Vanderbilt University Board of Trustees.

Thousands of Vanderbilt students and alumni met downtown for a parade, with Tennessee governor Alf Taylor riding in the lead automobile. Decorated in orange and black, the automobile began the parade at Twelfth and Broadway, weaving through the side streets to a reviewing stand at the foot of the capitol building.

Leading the parade was the Vanderbilt University's band followed by the faculty. The medical department furnished some entertainment for the thousands who lined the streets, with the students dressing in costumes to fit their field of study. The med students were led by "Dr. Pill" and were closely followed by the freshman class parading in skulls and crossbones. The sophomore medical class was armed with pounding tin pans and skillets. Other creative instruments made of shinbones and certain sections of the human anatomy were also seen.

After the countless speeches, the automobile procession, escorted by the police and Tony Rose's band, proceeded to the new stadium.

Tales of Commodore Gridiron History

The stadium had originated with a fund that began with the university lending half of the projected cost of $300,000 to the Athletic Association. The balance was to be raised by the alumni. The ambitious goal was to play the first home game in the twenty-two-thousand-seat stadium in October 1922.

Construction of the stadium was managed in several months after the plans were completed in January 1922. A local firm was awarded the construction contract, with Vanderbilt alumni engineers and architects supervising the actual work. Construction on the vacant lot began in February.

The field was completed in June, and the last of the concrete was poured on September 29. The height of the stands was thirty feet above the field on the west side, and the east side rose to seventy feet.

A *Tennessean* reporter described the field from the new press box on the day of the game:

> *The field was beautiful sight. It was absolutely clean and the grass was green except for a few brown spots. The goal posts were of iron pipe and padded so that no injury could come from a fall against them.*
>
> *They were wrapped in the respective colors of Vanderbilt and Michigan. Each 5-yard line was numbered with a letter plate so that there was no trouble in telling the exact position of the teams at a glance. It seems that a small boy is foiled at last. A number tried to slip in, but the height of the stands was too much for them.*

Three airplanes flew over the field at a height of a thousand feet while the Vanderbilt band played "America." The fans in the stands stood as Governor Taylor delivered the opening dedication speech. The field was dedicated to the late Dr. William L. Dudley, the founder of athletics at Vanderbilt.

While the band played "The Star-Spangled Banner," Mrs. Vanderbilt raised the Vanderbilt flag, the governor's wife raised the American flag and Michigan sponsors raised the Michigan flag.

After the dedication program, one of the airplanes, piloted by Lieutenant Herbert Fox of the 136th Aero Squadron, swooped down over the northern goal posts. Two hundred feet above the field, Fox dropped the game football that was wrapped with the colors of Vanderbilt and Michigan.

The ball fell near Vanderbilt head coach Dan McGugin, a Michigan graduate, who caught the ball on one bounce. He handed the ball over to

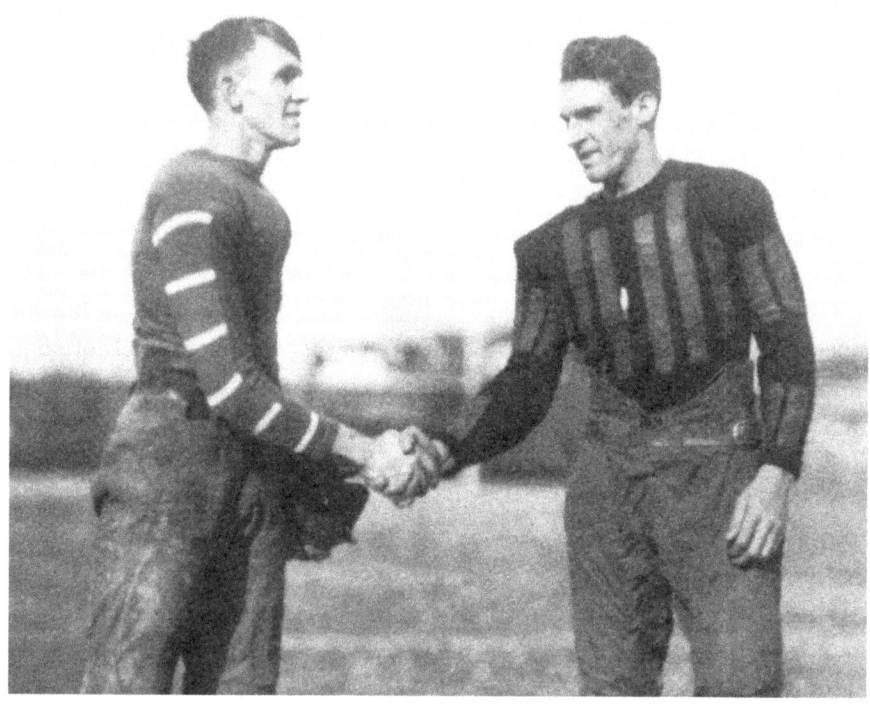

Vanderbilt captain Jess Neely (right) greets the Michigan captain before kickoff of the first game played on Dudley Field. *Courtesy of Vanderbilt Athletic Communications.*

his brother-in-law and Michigan head coach, Fielding Yost, who was in his twenty-second year with the Wolverines. No attempt was made to catch the ball since a similar stunt in Texas resulted in an injury to the receiver.

Vanderbilt and Michigan had met on seven occasions since 1905, with the Wolverines winning all of them. The mighty men from the Big Ten were favorites to win this dedication game. The 2-0 Commodores were coming off shutout wins against Maryville and Henderson-Brown.

An estimated eighteen thousand fans stood to their feet as Vanderbilt captain Jess Neely led his Commodores onto the field for the 2:15 p.m. kickoff. Each team met at the center of the field to pose for photographs. Michigan won the coin toss, and Vandy all-American Lynn Bomar had the honors of being the first to kick off in the new stadium.

In an era of primarily running the football, each team's defense's was relentless and didn't give up much ground. The game became a battle for

Tales of Commodore Gridiron History

field position as the punters dominated the game. The Vanderbilt band playing "Vanderbilt Forever" tried to inspire the fighting Commodores.

The only threat in the first half occurred when Vanderbilt was forced to punt from its seven-yard line. Vandy punter Scott Neil only managed a twenty-yard kick. Michigan drove to the Commodore two-yard line before facing a fourth-down situation.

From a kick formation, Michigan faked the kick, and end Harry Kipke took the ball off the right tackle but was stacked up at the Vanderbilt one-foot line. A Vandy player, trying to gain an advantage, pushed himself off the goal post and into the pile of players. The crowd in the stands went wild.

The kicking game continued for control of the contest, with Michigan's Kipke's punting ability equaling Neil's. The halftime score was Vanderbilt 0, Michigan 0. The band played Vanderbilt songs and formed its traditional "VU" periodically throughout the game.

In the third quarter, a Vanderbilt student, "freshman Gross, the best cheerleader Vanderbilt ever had," ran around the field waving handkerchiefs and yelling. He attempted to fire up his Commodores and break the stalemate. Thousands of fans responded and waved their white hankies.

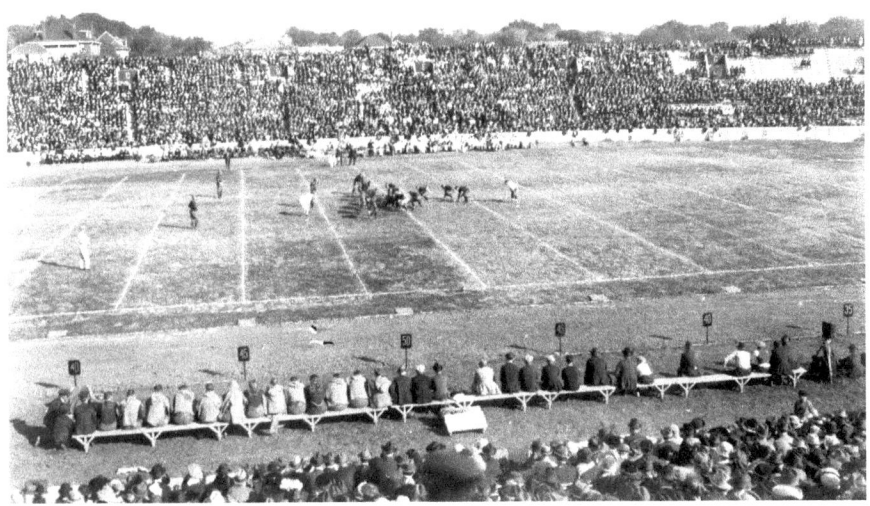

Game action in the 1922 Michigan versus Vanderbilt game, which ended in a scoreless tie. *Courtesy of Vanderbilt University Special Collections and Archives.*

A fourth-quarter field goal attempt by Michigan was low and fell harmlessly into the end zone for a touchback. The gun sounded and the game ended, 0–0. To show their delight, the fans whirled about three thousand seat cushions onto the field. They did not lose to the mighty Wolverines.

Vanderbilt recorded seventeen punts in the game compared with Michigan's ten. "Stadium Day" was a success, and so was the 1922 season. The tie would be the only blemish on the Commodore record as the team finished the season undefeated with an 8-0-1 record.

COMMODORES WIN FIRST NORTHERN GAME IN 1924

The headlines on the front page of the *Tennessean* dated November 23, 1924, read, "Vanderbilt Wins First Time in North." The fuss was the 16–0 Commodore win over the powerful Minnesota Gophers. The Gophers had stopped the great back from Illinois, Red Grange, the previous week. The huge upset earned front-page newspaper coverage. Blinky Horn of the *Tennessean* wrote:

> Those strife scarred but undying traditions of the Southland brought Vanderbilt to a 16–0 triumph over Minnesota in Memorial Stadium here today. After more than half a century the charge of Pickett's men at Gettysburg was re-enacted. That same matchless courage which guided the ragged Rebel band up those shell-torn heights, led the Commodores to conquest.
>
> It was the first victory of a Vanderbilt eleven ever attained across the line which divorces Dixie from the North. Mirrored here on Yankee sod today was that unconquerable spirit which enabled forefathers of the Commodores back in '63 to jest through a tempest of musketry and canister and grape.
>
> Vanderbilt won because its play reflected all the legends, all the chivalry, and all the courage of Southern history. Because its spirit never for a second faltered. Because it grinned at frowning barriers and went through. Because its valor could not be scarred by the flame of that attack which burned Illinois to a crisp a week ago. The team, which stopped Red Grange, was stopped by a sprit immune to any ingredient of defeat.

Vanderbilt Football

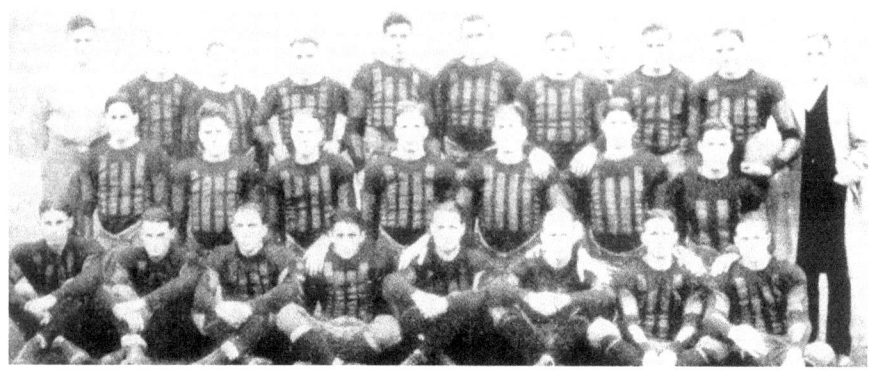

The 1924 Vanderbilt football team was 6-3-1, with its first victory against a northern team. The Commodores won at Minnesota, 16–0. *Courtesy of Vanderbilt Athletic Communications.*

It appears that Mr. Horn is a good ole southern boy! This writer's great-great-grandfather, Tom Joplin, who was a Confederate scout (spy), would have felt proud. Sports writers today rarely write with such historical perspective any more.

Dan McGugin's Commodore club was 4-2-2 entering the game. The Gophers were coached by William Spaulding and were 3-2-2 after the 20–7 victory over Illinois. The game was scheduled for 2:00 p.m., with a crowd of sixteen thousand. Vanderbilt was outweighed and a much less experienced team. They were huge underdogs. In this era, southern football was not met with such high regards in the North.

Vanderbilt scored first after eight minutes were gone in the first quarter. Vanderbilt tackle Bob Rives opened a hole for fullback Tom Ryan, who blasted his way into the end zone to cap a sixty-three-yard drive. The conversion failed. Vanderbilt led 6–0. Hek Wakefield added a field goal, and Fred McKibbon tossed a ten-yard pass to Gil Reese for the final Commodore touchdown. Wakefield added the conversion to make the final score Vanderbilt 16, Minnesota 0.

The *Tennessean* continued:

> *Outplayed were the Gophers. Bill Spaulding, Minnesota mentor graciously conceded that. But above all, the Gophers were outfought. The Gophers were out kicked and out passed. Tom Ryan booted his way to the loftiest heights his toe has ever led him. Fred McKibbon left Minneapolis dizzy with his crafty timing of aerial shots.*

Tales of Commodore Gridiron History

Wakefield chose his plays with excellent judgment. His tackling forced the Gophers frequently to take time out, and he repeatedly threw Minnesota backs for losses. There is a sketchy chronicle of the score incubation. But it was the Commodore defense which stripped naked the laurel tree to adorn Bob Rives, Neil Cargile and all the rest. Bob Rives climbed to the crux many times in the past to bring back decoration from gridiron gods. His other upward journeys were trips to the crest of a molehill. This day he reached Mt. Everest.

The intersectional game attracted so much pregame attention that Vanderbilt students and supporters gathered at Dudley Field to receive telegraph updates on the contest. An estimated 4,500 people were in

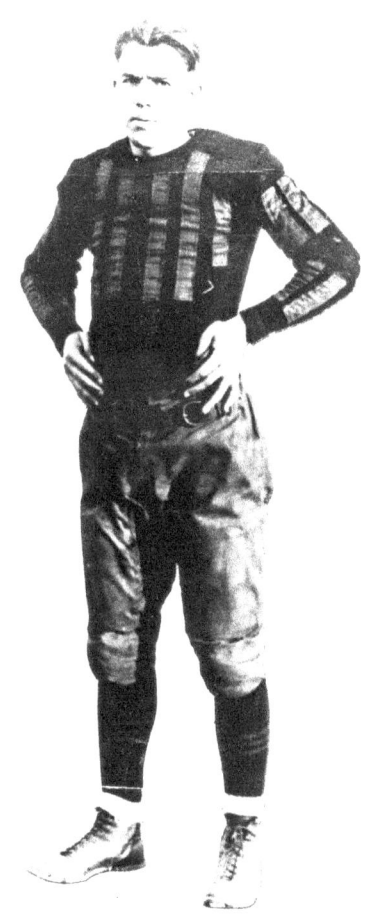

Henry "Hek" Wakefield was a two-way standout for the Commodores and in 1924 was named a First Team all-American. *Courtesy of Vanderbilt Athletic Communications.*

attendance. The *Tennessean* reported on the exuberant fans when news reached them of the Commodore victory:

> *All restraint fled yesterday afternoon as a telegraph wire flashed to Vanderbilt stadium the news that a Commodore team had won its most glorious victory of a decade. Man became monkey. He sprang into the air, and wrapped his prehensile tail around an imaginary coconut tree, and tried to scream the stars into alarm.*
>
> *Vanderbilt, the under-favored, became Commodore the triumph, the king of all sons, charted or uncharted. Vanderbilt had won! Oh, boy! Those were just the 4,500 who came to the stadium and volunteered heroically to stand by the old ship, sink or float. When the news flashed through the streets, 123,000 men, women and children took the cry. This is the directory census of the Nashville directory. That is how many people joined in that mad hallelujah. An extravagant estimate? Maybe. But last night even Davidson County wasn't big enough to dam the surging emotions of a populace gone victory mad.*
>
> *College hall, out on Vanderbilt campus, it an old historic building. This stone foundation has withstood the cries of victory and the groans of defeat for, lo, these many years. But last night its firm old foundation faced a new crisis. Hundreds of it undergraduates, post-graduates and non-graduates massed in front of its portals with a song such as never known, and in reparation for a parade that will be remembered here long after other parades will have been forgotten.*

It was reported that the parade went across the Vanderbilt campus all the way downtown to Church Street. Wherever the parade traveled, traffic was put into a standstill, allowing the mass of Vanderbilt supporters to enjoy their victory.

The Vanderbilt win was said to have been the greatest intersectional win for a southern team at that time. Vanderbilt only played eleven men with no substitutes. The lineup included Hek Wakefield, Neil Cargile, Fred McGibbon, James Walker, Bob Rives, Zach Coles, Kenneth Bryan, Jesse Keene, Gil Reese, Bill Hendrix and Tom Ryan.

LYNN BOMAR WAS A COLLEGE HALL OF FAMER

When former Vanderbilt all-American football player Lynn Bomar died in 1964, his passing was front-page news. The "Blonde Bear" was the second Commodore football player (1921–24) to be selected to the College Football Hall of Fame in 1956. The offensive and defensive end's last collegiate game ended suddenly in 1924 against Georgia in Athens.

Blinky Horn, writer for the *Tennessean*, wrote about that terrible day in Athens:

> *Yet while Commodore stand and gaily flutter, to defy defeat, there is wretchedness at Vanderbilt that cannot be banished. Not because disaster has left an ugly stain. Vandy is shrouded in woe because Lynn Bomar fell mortally wounded upon the battlefield.*
>
> *They carried him away in the third quarter, never to return. For Bomar only the recollection of the honor that was his remains. He will come no more to uphold the ensign of the black and gold.*
>
> *There is a second cante paralysis gripped him. The celebrated Commodore hero now lies in bondage, his muscles rigid, his body irresponsive to the summon of his mind.*
>
> *A kick upon the jaw came in the second period as he stepped a Georgia play. The crushing blow blasted out a tooth. But Bomar remained, with gigantic courage at his post. Giddiness seized him. And finally the monster moleskin man limply was carried away. The giant who so often in the past blocked the Bulldog path is now a broken mass.*

Lynn Bomar was the first great end of the Dan McGugin era. He was named to the Walter Camp all-American team in 1923, but his college career ended the next year after suffering a head injury. *Courtesy of Vanderbilt Athletic Communications.*

Oft shall the summons come to Commodores. Bomar will hear, but he cannot answer. The end of the trail has come for the big Blonde Bear.

Vanderbilt lost the hard-fought game to the Bulldogs, 3–0. Bomar suffered a brain hemorrhage after he made a severe tackle. His life was threatened for several days as he lay in a hospital bed paralyzed from the waist down. He never played another down for the Commodores. Bomar did have a miraculous recovery, but his playing days were over. Or so it was thought.

The next year, Bomar was playing professional football in the infant National Football League. In two seasons (1924–25) with the New York Giants, Bomar played in twenty games, scoring five touchdowns as a receiver. Bomar's professional career ended with a dislocated knee.

Tales of Commodore Gridiron History

In Russell and Benson's *Fifty Years of Vanderbilt Football*, they wrote:

> *The Blonde Bear was one of the world's greatest football players, who never missed an open-field block. When one considers that he made Walter Camp's All-America when he was backing up the line on defense and blocking and catching passes on offense, his greatness is realized.*
>
> *Bomar never used his great strength except legitimately. He spared every man he could. He played fairly and cleanly. Bomar's recuperative powers amazed physicians and although he could play no more for the Gold and Black, he was on the bench every game.*

Bomar was a native of Bell Buckle, Tennessee, where he first attended Webb School in his hometown. He then played football at the old Fitzgerald and Clarke School and finally at Castle Heights in Lebanon. At Vanderbilt, he played four years, including fullback and halfback. Bomar also excelled as a Commodore basketball and baseball player.

Vanderbilt was playing in the Southern Conference during Bomar's playing years. He was one of the first southern football players to make the Walter Camp all-America team in 1923. He led the Commodores to a 7-0-1 record as a freshman (1921) and was credited for saving five touchdowns in the Georgia game.

In 1922, Bomar's Commodore club was 8-0-1. The only blemish from that historic season was a 0–0 tie against powerful Michigan. That game was also the first game played at the newly christened Dudley Field.

During the period between 1934 and 1939, Bomar was a deputy U.S. marshal living in Nashville. Bomar was with the Tennessee Safety Department as head of the Nashville Division but resigned to head the combined police and fire departments of Knoxville for two years. By 1943, he had returned to the highway patrol to lead the Knoxville Division.

Bomar stayed active within the state for years serving in the capacity of commissioner of safety for Tennessee, working for Tennessee Motor Transport Association, Universal Tire and Appliance Company and Tennessee Superintendent of Public Works. Bomar was appointed the warden of the Tennessee State prison in Nashville, where he served until his death at age sixty-three.

Nashville's legendary sports writer and Vanderbilt alumnus Fred Russell wrote the following about Bomar in his book *Bury Me in an Old Press Box*:

Lynn Bomar was inducted into the College Football Hall of Fame in 1956. *Courtesy of Vanderbilt Athletic Communications.*

As a freshman I had pledged Kappa Sigma fraternity, which at that time had many varsity athletes. Among them was Lynn Bomar, selected All-American end in 1923. Bomar held one of the choice jobs given football players: a street-car "spotter." In this capacity Bomar's duty was to check on whether the conductors rang up all the fares. He was required to fill out a brief report on each street-car ride he made, the conductor's number, the registers reading, etc.

For each report the Nashville Railway and Light Company paid 25 cents, though limiting his earnings to a maximum of $75 a month. Bomar subtracted his job to me, and we split $75 every month. I also had the

responsibility, as a freshman, of awakening Bomar in time for him to get to classes, and at the end of the school year I did this one morning by rolling the biggest lighted firecracker I ever saw under his bed.

When it exploded I feared the whole corner of the fraternity house had been blown off, and I was so scared that even Bomar in his BVD's chasing me across the street and deep into the campus couldn't catch me.

During their playing days at Vanderbilt, Gil Reese, an all-Southern halfback for the Commodores, said about his close friend: "He would never let them jump on me. Whenever anyone would threaten me, Bomar was always right there to say, 'Keep your hands off that boy.' They always did, too. Bomar always looked after me, and he always called back to me when we started on end runs. No one could run interference like Bomar."

In January 1956, when Bomar was officially named to the College Hall of Fame in New Brunswick, New Jersey, he said: "I just wish all the men who played football with me at Vanderbilt between 1921 and 1924 could also receive this coveted award. They deserve it more than I do. After all, they made it possible for me to be chosen."

THE LEGEND OF DIXIE ROBERTS

This interview between the late Dixie Roberts and Bill Traughber occurred in December 2002. Roberts was ninety-three years old at the time.

William Clyde "Dixie" Roberts was involved in an incident that, in the twenty-first century, would have brought the NCAA to the Vanderbilt campus for an investigation. This ancient incident involved Vanderbilt's legendary coach, Dan McGugin, and Roberts, who played for McGugin (1930–32). The "infraction" concerned a car:

> Coach McGugin bought a '30 Model Coup and had brought it up to Beersheba Springs, Tennessee, near where I lived in McMinnville. A lot of people from Nashville would go there for the summer. He came down one day that summer in 1932 and was hit with this downpour of rain.
> Over the river there was a crooked bridge. Well, he drove that car right off that thing into the river. And the car was completely submerged. With the downpour, that little river would get big before you could say "scat." I heard that the insurance company was going to give the car to Ford Motor Company if they could get it out of the river. So, I called Coach McGugin and told him not to give that car to them, but to give it to me.
> So he told the insurance company to give the car to me. When the river went down, I got a couple of the boys, and we were able to get a truck out into a field. We pulled the car right out. I took it home and set it out in the sun to dry out. The boys at the Ford Motor Company in McMinnville helped me get the parts to get it running again.

Roberts was raised in McMinnville, Tennessee, and became a legend while breaking records on the prep football field. Roberts's father owned the Dixie Hardwood Company, and the local farmers called his father "Dixie"—son Clyde became "Little Dixie." The nickname was carried over as his legend grew. When Roberts was born, William Howard Taft was president of the United States.

In his senior year (1928) at McMinnville, Roberts led the "Big Blue" to a perfect 10-0 record and a state championship. This would be McMinnville's only undefeated season in its gridiron history. While recordkeeping in those days is sometimes questionable, Roberts did record 3,690 yards as a senior, which includes one game totaling 520 yards rushing.

Dixie Roberts was an accomplished Tennessee high school running back from McMinnville and broke several state records. *Courtesy of Bobby Newby.*

When we got through eight games in our schedule, Cleveland and Carthage were claiming the state championship, as were we. So the coach over at Cleveland called up our coach, and a game was arranged. We always played our games at the fairgrounds. They came in a day early and practiced.

They kicked off to us, I caught the ball and ran it back for a touchdown. I kicked the extra point. We kicked the ball off and held them on downs. They punted; I caught it and ran it back for a touchdown. That happened again and again. The score was 26-0, and we had not run a play from scrimmage.

Then we went over to Carthage, and they did have a good team and passer. They had just sold their tobacco and were betting up a storm. We didn't know about that, but they hadn't been scored on. On the third play of the game, I scored on a long touchdown run. That discouraged them so much that we went on to win the game and the state championship.

Roberts scored eighty-five career touchdowns and rushed for 6,730 yards, with forty-one touchdowns in one season. Roberts received a letter from the Tennessee Secondary School Athletic Association in 1993 verifying his listings in the football section of the state records.

College recruiters swarmed to the small community of McMinnville to secure Roberts's football services. Notre Dame reportedly was interested. Roberts wanted to stay close to home, so it came down to Tennessee and Vanderbilt for college.

"It was close. I knew some people that were in Vanderbilt. A recruiter for Knoxville tried his best to recruit me. But, I went to Knoxville to watch a game where Tennessee played Florida," said Roberts about his college selection. "[Coach Robert] Neyland got on this great big ole boy that was a tackle who was doing the best he could. Neyland was too rough on him. I was asked if I was going to the University of Tennessee. I said, 'No, I couldn't do it.' I wouldn't put myself in that position. If he talked to me like that, there would be the damnest fight you ever saw."

Freshmen were not allowed to play on the varsity in this era of college football. However, Roberts was on the Commodore freshmen team that was 5-0. Considered one of Vanderbilt's best freshmen team, it featured Pete Gracey, "Chuggy" Fortune, Jim Beasley, Marion Talley, Julian Foster, Tom Henderson and Roberts.

The immortal McGugin began his tenure at Vanderbilt in 1904 and coached through 1917 and again in 1919-34; in thirty years he is the Commodores'

all-time winningest coach (197-55-19). Roberts said that McGugin liked to delegate the coaching to his assistants as he neared retirement.

Vanderbilt was 8-2 in Roberts's first season on the varsity in 1930. He scored his first collegiate touchdown while receiving a pass in the first game against Chattanooga. Roberts did not start in the Commodore backfield that year, yielding to the experienced players.

In the first game of the 1931 season, Western Kentucky came to Nashville, and Roberts learned a valuable lesson about the rigors of college football. The lesson came from his backfield teammate from the previous year. By now, Roberts was starting as a halfback:

> *Jess Thomas graduated and went to Western Kentucky as a backfield coach. He told his players that if they would get me out of the game, that they would have a chance to win. Along during the game, I felt several times being stepped on.* [They] *were doing that intentionally with those cleats on.*
>
> *Once this happened over in front of our bench. I looked up at the old boy and said, "You son-of-a-b…, before you leave Nashville, I'm going to whip your* [tail]*," and Josh Cody* [Vandy assistant coach] *heard me and took me out. He said, "Dixie, they will bar you from the conference for talking like that."*
>
> *About four or five plays later, they had put Larry Burton in. He made a pretty good run, and they tackled him on the cinder track (area between the benches and retaining wall). He came up fighting with his headgear, and a whole bunch of them jumped in and started fighting. One boy said, "Who hit my brother?" I said, "I did you son-of-a-b…," and this was a fellow that had been stepping on me. And I hit him and knocked him down. They put him on a stretcher and carried him out of there.*

Vanderbilt finished that year at 5-4. The Commodores were at this time members of the Southern Conference. The Southeastern Conference would be established in 1933. Roberts never played a game in the SEC as all his college days came before its existence.

Roberts also played on defense as a safety. He was known for an unrelenting stiff-arm and was asked if he played a rough style of football.

"Yeah, a little bit," answered Roberts. "If they are going to come into you and try and do it to you, then I always felt that I could take care of myself."

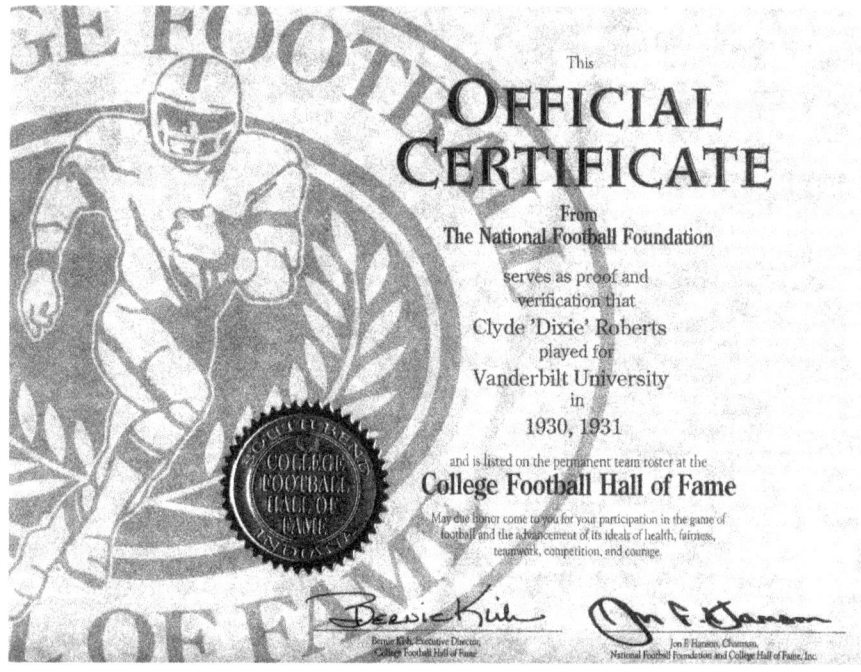

Dixie Roberts played three seasons (1930–32) for Vanderbilt. *Courtesy of Bobby Newby.*

Roberts said that, naturally, the Tennessee game was the biggest of the year for him and Vanderbilt. One of the toughest players he went against was the Vols' all-American running back, Beattie Feathers. In three seasons of varsity play, Roberts was 0-2-1 against the Vols.

In the 1932 game, and in Roberts's senior year, the UT game resulted in a scoreless tie. The only score of the game was called back in the second half. Feathers caught a pass but was called for stepping out of bounds at the Commodore twenty-seven-yard line. He had to be shown his footprint where he stepped on the line:

> It happened right square in front of the Vanderbilt bench, and some little fellow [a UT ball boy] ran out and tried to pat it down where his foot stepped. Cody reached over and picked him up and set [him] back over. The Tennessee guy was trying to cover up the footprint. The referee took the game away from us.
>
> In this particular game, we punted, and it looked like it was going to stop a yard in front of the goal line. We rushed over, and [Charles]

Tales of Commodore Gridiron History

Leyendecker and I were about to cover the ball. We were coming in on the thing; the ball came up and hit a Tennessee fellow on the back. We fell on it, and that means the ball belonged to us. But he gave that damn ball to Tennessee.

He said that Leyendecker pushed him. There's nothing in the rules that says you can't push him. You can knock him on his head if you want to. Neyland was a pretty rough customer. He had a lot of power in the conference, and the referees favored him.

The game's leading rusher was Roberts with seventy-nine total yards, besting Feathers's sixteen yards. Tennessee concluded the season at 9-0-1 and shared the Southern Conference championship with Auburn. The Commodores finished with a 6-1-2 record.

Roberts earned an engineering degree from Vanderbilt and later entered the insurance business. He retired in 1964. Roberts has followed Vanderbilt football since he graduated in 1933. Roberts was asked about the differences between today's players and the players of his day.

"They are a lot bigger; there's no question about that," Roberts said. "They don't have to play offense and defense, too. That's the big difference. They would wear each other out; they couldn't take all that contact today. Another thing, the size of the football has changed since the time I picked up the first one."

FANS END 1932 TENNESSEE GAME

In November 1932, the United States was in the early stages of the Great Depression. That month and year brought Nashvillians two opportunities to vent their frustrations. On November 8, 1932, incumbent president Herbert Hoover was ousted from office in favor of Franklin D. Roosevelt.

Just four days later, University of Tennessee's football team arrived in Nashville for its annual battle with Vanderbilt. Even with a Depression, an overflowing Dudley Field crowd interrupted the game several times, causing the eventual premature ending of the contest.

The Vols rolled into Nashville with an unblemished 7-0 record under the guidance of legendary coach Robert Neyland. Dan McGugin led Vanderbilt with a 6-0-1 slate. Both teams were members of Southern Conference and in line for the conference championship. The Southeastern Conference would be organized the next year.

The results of the game were front-page news in the *Nashville Tennessean* with a caption that read: "Seething Mob Shares Field With Gridiron Enemies Here."

Dudley Field was only ten years old, with a seating capacity of twenty-two thousand. Temporary bleachers were also installed in the north end zone. As the Vanderbilt band entered the stadium at 1:20 p.m. for a 2:00 p.m. kickoff, the bleachers were full, and three-fourths of the remaining seats were occupied.

A few minutes later, the Vols made their appearance onto the field, and that's when problems ensued. The *Tennessean* reported:

Tales of Commodore Gridiron History

Vanderbilt's Tom Henderson (with ball) always played without a helmet because he believed that it got in his way. *Courtesy of Tom Henderson III.*

> *And then the gate-crashing started. Between 2,000 and 3,000 frenzied persons stormed through the gate to the temporary north end bleachers—a surging wave of thundering humanity.*
>
> *The blue coats had hardly checked the flow of humanity at the north end before another rush was made just east of the Palmer field house. This time several hundred, in lockstep style climbed onto the stone fence leading to the field house. Then they went on top of the equipment house and jumped into the north end bleacher section. They were stopped jumping from over but the top of Palmer field house looked like a crow's nest, it was so black with humanity.*

The Palmer (actual name is Parmer) field house remains to this day. It's the small stone building behind the north end scoreboard near Memorial Gymnasium. The Southern Conference rule prohibiting spectators on the sidelines was in severe jeopardy. Fans were also bold enough to sit on the Commodore benches on the west side. The police (men in blue coats) were helpless as they were brutally outnumbered.

It was also reported that the general admission crowd on the field was blocking the view of the box seats patrons. By the time the Vandy team arrived fifteen minutes before kickoff, it was estimated that twenty-five thousand to thirty thousand fans had occupied every stadium seat, the aisles and areas between the retaining wall and both benches.

McGugin was asked to announce that the game would not begin until the spectators were back against the stands and off the cinder paths. They reluctantly succumbed to the demand.

Now for the game, or least some of it. Vandy won the coin toss and was led onto the field by its all-American center, Pete Gracey, and backs Dixie Roberts and Chuggy Fortune. The Vols were led by their all-American, Beattie Feathers. Feathers was a halfback and one of the country's best punters.

The defenses would determine the outcome of this game as interceptions and rough tackling prevented either team from scoring in the first half. Gracey injured his knee in the first quarter and was out for the rest of the game. The *Tennessean* reported:

> *For the Vols tackled savagely. The Commodores were as vicious. Medical attendants were called so often that the officials were on the point of deciding to allow them to remain on the field so their first aid could be brought quicker.*
>
> *The Vols hit hard. They hit harder than that. They were shoulder blocking savagely. Vandy struck with terrific velocity. Breezy Wynn was so battered after the first half that Middleton replaced him and performed nobly.*

Wynn was the Vols' fullback. "I have rarely seen such a defensive exhibition," said Walker Powell, one of the officials.

With a scoreless first half, the impatient crowd once again became the story. They began to creep toward the field and lined the sidelines. McGugin and Neyland removed their teams from the field and back to the dressing rooms. After trying vainly for twenty minutes to remove the crowd back to the walls, the officials firmly announced that if they were not back in two minutes, the game would be forfeited to Tennessee.

Finally, after thirty minutes of delay, the second half began. A writer from a Knoxville newspaper capped the second half:

> *In a game featured by super-savage tackling and murderous blocking, Tennessee and Vanderbilt waged a defensive masterpiece in their traditional battle here this afternoon before a mad, surging throng, numbering close to 30,000 fans. The final score was Tennessee, 0; Vandy, 0; in favor of Auburn.*

Tales of Commodore Gridiron History

There were no red flares of victory lighting over Middle Tennessee last night. All is calm and quiet. The deadlock served only to remove, at least temporarily from the championship squabble and pave the way for Auburn's triumphant march to the throne room.

The scoreless game only produced one player crossing the goal line, but it was nullified. In the fourth quarter, Feathers sprinted into the end zone for a touchdown after catching a pass. The officials said that he stepped out of bounds at the Commodore twenty-four-yard line. Feathers was taken to the spot where he apparently stepped out of bounds and shown his footprint.

The crowd once again began to prowl the sidelines. Police and reserve players attempted to hold them back but failed. In the closing minutes, Vanderbilt's Tom Henderson caught a twenty-seven-yard pass from Roberts, setting up a first down at the Vols' twenty-two-yard line. The unrelenting crowd was back on the edge of, and actually on, the playing field.

The frustrated officials had had enough. The Henderson reception would be the last play of the game. With only three minutes left to play, the officials

Pete Gracey was an anchor on offense and defense. He became an all-American and was recognized as one of the greatest centers in Vanderbilt football history. *Courtesy of Vanderbilt Athletic Communications.*

sounded the gun and proclaimed the game over. The Vanderbilt officials were severely condemned for overselling the general admission seats.

A newspaper reporter wrote about his disdain for the unruly fans:

> *The mammoth audience defied police, scoffed at pleas to move into the cinder path, and not until the officials had threatened to forfeit the game to Tennessee, 1 to 0, did the sulky retreat beyond the boundary lines. Some said there were 25,000 there. Some thought there were 35,000. Nobody will ever know. For the flimsy fences were beaten down. The inadequate police forces was helpless.*
>
> *There has never been such an assemblence in Dudley stadium. There has never been such utter disrespect by a crowd for the rights of players. The overflow swept completely out of control. The temporary stands collapsed in one section. The thin wire was torn down by the momentum of a crowd intent upon getting into the arena.*

Vanderbilt recorded 182 total yards, while Tennessee tallied 118. The Commodores' backfield of Roberts and Fortune formed the game's leading rushers with 86 and 72 yards. Feathers led the Vols with 47 rushing yards.

"Considering that we lost such a valuable player as Pete Gracey so early in the game, I thought that Vanderbilt was very fortunate in getting out with a tie," McGugin said after the game. "Tennessee has an unusually fine defensive team and they never quit fighting. It was unfortunate that the last period was shortened for we might have been able to do something on that last drive."

Neyland was equally concerned about the scoreless duel. "It was naturally disappointing to the Tennessee coaching staff," he said. "Our record for the season was marred, but after all is said we probably were lucky to tie. I thought the Vanderbilt team showed an unusually great defense. Fortune and Roberts are two hard-driving backs that will give any team trouble."

Vanderbilt lost to Alabama, 20–0, two weeks later and concluded the season 6-1-2. The Vols and Auburn finished their respective seasons with identical 9-0-1 records. Both teams were declared co-champions of the Southern Conference.

But isn't it refreshing to read about Vanderbilt fans arriving at the game before kickoff!

COMMODORES VISIT WITH PRESIDENT FRANKLIN D. ROOSEVELT

One of the advantages of winning a national championship in football is the traditional visit with the president of the United States at the White House. On November 2, 1934, the Vanderbilt football team made such a visit. Coach Dan McGugin's Commodores were in Washington, D.C., to play George Washington University the following day.

Marvin H. McIntyre was a personal secretary to President Franklin D. Roosevelt, a graduate of Battle Ground Academy (class of 1897) and Vanderbilt University (class of 1901). With the Commodores in town, McIntyre was able to arrange a brief visit with his old college team and FDR. The meeting was in FDR's office.

Blinky Horn of the *Tennessean* gave this report of the greetings:

> *Some of the boys got a lucky break today and had a moment or so with President Franklin Delano Roosevelt, which to a heap of folks was far more important than whether Vandy wins tomorrow from George Washington University.*
>
> *They got in touch with him through Marvin McIntyre, head secretary for F.D.R., who once went to Battle Ground Academy at Franklin.*
>
> *Naw, not Roosevelt.*
>
> *He went to Harvard.*
>
> *It was McIntyre who went to Battle Ground.*
>
> *Which makes some people wonder why Josh Cody and Nuck Brown and other celebrated grads of that famous institution of learning failed*

to get a post. Surely they would be entitled to something like Minister of Timbuctoo.

Mr. President did not talk to any of the boys about how he stands on the California EPIC plan, but he beamed his celebrated smile while smoking a cigarette (none of the boys could detect the brand although none were blindfolded) and chatted gaily for a very, very little while during the press conference.

Horn must not have realized that McIntyre was also a graduate of Vanderbilt University. A search at the Franklin D. Roosevelt Library at Hyde Park, New York, indicated that the team only met with the president from 4:10 p.m. to 4:20 p.m. There were not any records or photographs located.

McIntyre was born in LaGrange, Kentucky, on November 27, 1878. He began a career in journalism in 1905 when he became city editor of the *Washington Post*. McIntyre left that post to become special assistant to the secretary of the navy and served as a member of the Committee of Public Information and as publicity director for the U.S. Navy (1917–21).

McIntyre was also a valuable worker on Roosevelt's political campaigns. In July 1937, he was appointed secretary to the president and remained in that capacity until his death in 1943. There are no records found to indicate that McIntyre played any sports at Vanderbilt.

The *Nashville Tennessean* reported on the Vanderbilt football team's visit with President Franklin D. Roosevelt in 1934. *Courtesy of the author.*

Tales of Commodore Gridiron History

The USS *Marvin H. McIntyre* was a Haskell Class attack transport ship that was named for FDR's old friend. The ship was launched in September 1944 and was decommissioned in 1946.

The newspaper reported that the team went on a sightseeing tour of Washington, D.C., and that the game was to be played at Griffith Stadium. The Commodores stayed at the Wardman Park Hotel. Also reported in Washington, D.C., area newspapers were glowing remarks about McGugin and his accomplishments with southern football.

The *Tennessean* reported on the game with George Washington:

> *The New Deal, as one and all know, started in Washington back in the spring of 1933. But Vanderbilt's New Deal did not start until they came to Washington today. After going eight periods with only one touchdown and being slaughtered by L.S.U. a week ago for their worst defeat in 14 years, Vandy came back today as 15,000 fans shivered, to win from the hitherto unbeaten George Washington outfit, 7–6.*
>
> *By their triumph the Commodores became the first foe of the Colonels to cross their goal line this season. Willie Geny made the touchdown and Dick Plasman kicked the point. Stopped colder on the ground than the temperature, the Commodores rode to victory through the air. Rand Dixon heaved a nine-yard pass to Geny for the touchdown late in the second quarter after Big Dick Plasman, from Miami where it's always June, blocked one of Tuffy Leeman's punt and Harry Guffee recovered on the nine-yard line.*

Vanderbilt only recorded three first downs in the game with fifty-five rushing yards and twenty-six passing yards. George Washington scored its points on a forty-yard pass completion for a third-quarter touchdown. But the extra point was missed as the Commodore defense held for the Vanderbilt 7–6 victory.

Vanderbilt had lost the previous week to LSU, 29–0. The Commodores came into the game with wins over Mississippi State, Georgia Tech, Cincinnati and Auburn. They would conclude the season with a 6-3 record (SEC, 4-3).

At the end of the year, McGugin would retire after thirty years (197-55-19) at the Vanderbilt helm. He was replaced by former Vanderbilt quarterback Ray Morrison.

GREER RICKETSON'S HISTORIC TOUCHDOWN

On October 23, 1937, the fourth-ranked LSU Tigers came to Dudley Field looking for a consecutive SEC championship. But a historic play by Vanderbilt head coach Ray Morrison ruined those plans.

Both teams entered the game undefeated, with LSU unscored on. Vanderbilt was 4-0, with wins over Kentucky, Chicago, Southwestern (Memphis) and SMU. More than eighteen thousand fans were in attendance. Greer Ricketson remembered:

> *This was a special game for the reason that they were highly ranked. According to Morrison, LSU was going to be particularly tough because they hadn't lost a game since the year before. We had not lost a game but had not done as well as LSU. I think he realized that it was just straight football, that we weren't going to win.*
>
> *So he thought he had to dream up something—some trick play that might affect the game. As it turned out, that's the way it worked [the historic play]. When we got ahead, our boys probably put out more effort and energy. And it swayed LSU a little. They were sort of dejected when that happened. So it worked the way the coach was hoping it would.*

Tales of Commodore Gridiron History

The *Tennessean* reported on the pregame festivals:

Ten minutes before the opening kickoff both teams having concluded their preliminary workouts, quit the field in favor of the band which played the national anthem while a crowd of more than 18,000 stood at attention.

It is winter weather and there is a brisk wind blowing across the field from the northwest. The temperature is 30 degrees and the skies are gray overhead, with no semblance of sunshine.

At 2:25 Vanderbilt came on the field with its starting lineup for a run down the terrain, Capt. Carl Hinkle of Vandy and James Warbrood of L.S.U. met for the toss-up. Hinkle won the toss and will defend the north goal. L.S.U., which was tardy coming of the field, will kick off.

Vanderbilt's Jimmy Huggins took the kickoff and raced to the Vandy forty-three-yard line for a return of thirteen yards. Halfback Clarence Reinschmidt was stopped after a yard gain on first down. He was stopped two more times, failing to gain a first down. Huggins punted the ball sixty-one yards to the LSU twelve-yard line without a return.

LSU was forced to punt with outstanding defensive plays by Vanderbilt's defensive tackle Buford "Baby" Ray. Huggins handled the punt at the Commodore thirty and was downed at the Vandy forty-three.

On first down, quarterback Huggins ran off the left guard for a six-yard gain. The *Tennessean* described "the historical play":

Ninety-nine per cent of the spectators and 100 per cent of the Louisiana team thought Dutch Reinschmidt, who had been almost under center at the snap had the ball as he raced to the South side of the field. He gradually faded back with three men in front of him for interference.

Greer Ricketson, playing left tackle, had pulled out as if to go around and block for Huggins. He took the ball from where Reinschmidt had intentionally fumbled or placed it on the ground, stopped momentarily while the Tigers stormed to the left. Then he came up from his crouch and started down the West sidelines with Preacher Franklin leading interference.

Ricketson raced fifty-one yards for a Vanderbilt touchdown. Joe Agee kicked the conversion, and the enchanted but bewildered fans stayed on their feet for several minutes. Vanderbilt led early in the first quarter 7–0,

and even the sportswriters were confused as to what had happened on that play, according to Ricketson:

> *We ran the play just as exactly as he* [Morrison] *told us the way to do it. The week before the game, he kept 11 of us out on the practice field while the rest of the team had gone in. He tried to keep it that secret while we practiced it on the field. It didn't wind up quite that secret. Some of the other boys found out about it. I had one friend who said he was in the stands and somebody had told him, but I don't think he knew the details.*
>
> *Before the game the coaches explained to the referee what the play was going to be and how it was going to be run. The coaches were afraid that the referees might blow the whistle and thought something was so unusual to stop the play. When we called the play, the quarterback turned around to the referee and said, "This is it." So he did and it worked just right.*

Ricketson said that the Vanderbilt line coach, Hank Frnka, didn't want to run the play. Frnka thought that it was too dangerous and might backfire. In order to win over Frnka, Coach Morrison named the play after his line coach. The players had a nickname for Frnka: "Pig Eye." Of course, they never said that in front of Frnka. When it was time to run the play, the

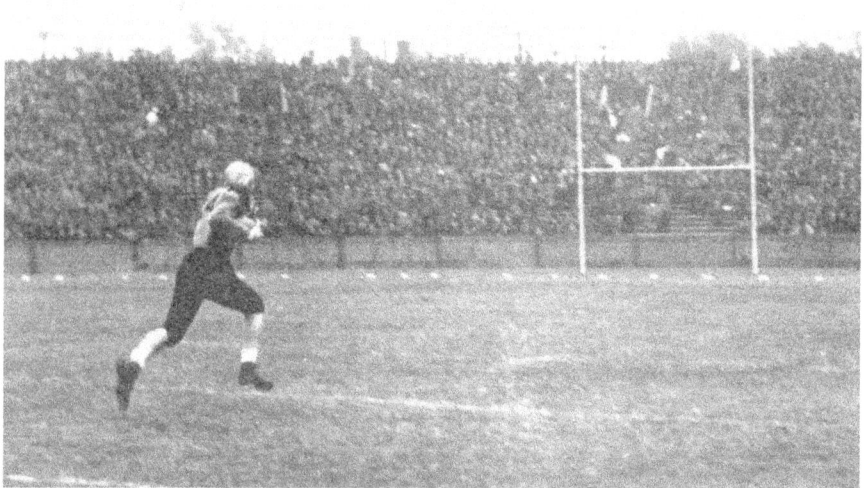

Greer Ricketson ran this "hidden ball" play for a touchdown to defeat LSU on Dudley Field in 1937. *Courtesy of Vanderbilt Athletic Communications.*

quarterback just said in the huddle, "Pig Eye." The players knew that it was time to run that special trick play.

In *Fifty Years of Vanderbilt Football*, published in 1938, the play was explained:

> Reinschmidt, getting the ball from center, spun, concealed the football on the ground behind a Vanderbilt lineman, then faked cleverly around his left end. The entire LSU team and even the officials went after him. Suddenly, Tackle Greer Ricketson, who had started out to follow the play, then fallen purposely over the ball, arose, picked up the leather and raced 50 yards for the touchdown as the mystified thousands asked each other what happened.

Movies of the play were run and rerun, but a question surfaced: did Ricketson's knee touch the ground? That question will remain unanswered without any certainty.

Ricketson said that he was chosen to run with the ball since he was the fastest lineman. Also, the year before, Ricketson had played end and was familiar with running with the football. Ricketson was asked to give his insight of the famous play:

> We were close to the right sideline in about middle field. I think we were on about the fifty-yard line or something like that. The reason we were over there, the play was designed for the running backs to make a wide end sweep to the left side. They were to try and pull the LSU players over that way to leave the right side of the field open.
>
> I switched from tackle position to guard and pulled out like a running guard back in the backfield. Then I did a fake stumble and fall. The guard and the tackle on the left-side assignment were to block still and not let anybody break through. They didn't charge into the defense; they tried to make a wall. My assignment was to stay on the ground to the count of three. The ball had been put on the ground by one of the halfbacks. He got under center like a T-formation, which we didn't play back in those days.
>
> He took the ball from the center and turned to his left, laid it on the ground behind the guard and tackle. He came up as if he had the ball and ran a wide end sweep. All the rest of the backfield was blocking for him. I picked up the ball and ran straight down the field, which was wide open.

The game remained 7–0 until the close of the fourth quarter. With only two minutes remaining in the game, LSU had the ball on the Vandy thirty-seven-yard line with a first down. Two plays later, a pass interference call on the Commodore defense placed the ball at the eighteen-yard line.

Jabbo Stell then caught a pass in front of the goal line and carried it in for the LSU touchdown. The score was now 7–6, with LSU's conversion attempt forthcoming.

On the extra-point attempt, the center's snap went past the kicker and holder and then bounced to the twenty-yard line. Vanderbilt's Ray and Ed Merlin jumped on the ball, securing a Vanderbilt one-point lead.

LSU kicked the ball to Vanderbilt, and the team ran out the clock. The fans stormed the field and carried the players to their clubhouse after the 7–6 win.

The South was stunned at the news of the LSU loss in Nashville and that an LSU fourteen-game conference win streak was broken. Vanderbilt gained 238 total yards against the Tigers' 90 yards. LSU only managed nine first downs compared to the Commodores' sixteen.

In the weeks after, Vanderbilt lost to Georgia Tech, beat Sewanee and Tennessee and concluded the season with a loss to Alabama. It wasn't known at the time, but if Vanderbilt (8-1) had beaten the Tide, they would have gone to the Rose Bowl. The undefeated Crimson Tide was invited to Pasadena.

Ricketson was asked whether, after so many decades had passed, people still ask him about that play.

"I will be at a place, and somebody will ask, 'You carried the ball, didn't you, in the Vanderbilt/LSU game?' "It has just hung on all these years. I've sort of kidded in a nasty sort of way. When I get to know some of the coaches over there at Vanderbilt, I tell them I wish that they would do something good so they'd quit talking about that LSU/Vanderbilt hidden ball play."

Ricketson passed away on July 31, 2007, at age ninety.

Carl Hinkle Was an Iron Man

Carl Hinkle (1935–37) displayed his iron man toughness during his senior season while playing all sixty minutes in seven games as a lineman.

"Determination" Willie Geny (1933–34) a former Vandy player and Hinkle coach, said at the time of Hinkle's death in 1992: "That was Carl Hinkle. He wanted to be the best, and he was the best. I remember he knocked three or four men out of that game [1937 Tennessee]. On one play, he hit Tennessee's George Cafego, and I remember Hinkle saying, 'He's through. Take him off.'"

Hinkle was born in Hendersonville, Tennessee, and attended Hickman County High School before graduating from Franklin's Battle Ground Academy. He was a dominant player in the line while playing as a sophomore and junior. But it was his outstanding play as a senior in 1937 that gained Hinkle a national reputation as one of the country's best football players. Hinkle was also the Vanderbilt team captain.

The Commodores, led by Coach Ray Morrison, entered the 1937 Tennessee game 6-1 on an autumn afternoon in Knoxville. Their lone loss at that point in the schedule had been with Georgia Tech. Coach Robert Neyland's Vols entered the game 4-2-1. Vanderbilt won the contest, 13–7, with two touchdowns and a missed extra point. A newspaper account of the game from *Fifty Years of Vanderbilt Football* read:

> *But for the gallant Carl Hinkle, Tennessee would have scored, perhaps won. This super-performer single-handedly clinched the victory for Vanderbilt.*

Carl Hinkle was a two-way player who became an all-American center in 1937. *Courtesy of Vanderbilt Athletic Communications.*

With only five minutes to play, a pass from Cafego to Eldred had set the ball on Vanderbilt's nine. Cafego was running wild, splitting the middle and circling the ends. It seemed impossible to head them.

On second down, he tore through center, where Hinkle met him with a murderous tackle that sent him from the game, groggy and reeling, just as the Commodore's captain had put out Cheek Duncan with a bone-rattling blast three plays before. Their exit took something out of the Vols.

Later the brilliant Hinkle intercepted Babe Wood's pass and lugged the ball to midfield. Morrison rushed in Pluckett and he killed the remaining seconds with three wide, sweeping end runs. It was the first victory over Major Neyland since 1926. Vanderbilt made only one line substitution, Henderson for Merlin.

The last game of 1937 was against undefeated Alabama (8-0) on Vanderbilt's Dudley Field on Thanksgiving Day. Though it was not known

Tales of Commodore Gridiron History

at the time, the winner of this SEC battle would be invited to the Rose Bowl to play California. Frank Thomas was the head coach for the Tide. Hinkle would be part of one of Vanderbilt's and the SEC's most historic plays.

Vanderbilt had the ball on its own forty-one-yard line with one minute left until the first half with the score tied, 0–0. Quarterback Bert Marshall gained four yards before the trick play. The Commodores tried to repeat the famous "hidden ball" play that beat LSU earlier in the season. In that game, Commodore tackle Greer Ricketson picked up the ball left on the ground to sweep around end for a fifty-yard touchdown.

Alabama must have been looking for the play, as they quickly recovered the exposed ball. The ball was marked on the Vanderbilt forty-four-yard line, and four plays later Bama scored on a touchdown pass before the half. The extra point was missed as the Commodores trailed at halftime, 6–0.

Vanderbilt came out in the third quarter fired up as the Commodore fans were roaring in the stands. Marshall would direct a fifty-three-yard touchdown drive with fullback Hardy Housman finding the goal line for a touchdown. The extra point was good, and Vanderbilt led, 7–6.

With six minutes left in the final period, the Tide lined up for a twenty-three-yard field goal attempt by a substitute end named Sandy Sanford—he was facing a tough angle, but the kick was good. Hinkle charged the ball but just missed the block by inches. The Commodores could not move the ball for a score in the final minutes, and Hinkle walked off the field in his last game with a disappointing defeat. Alabama won, 9–7, but lost to California in the Rose Bowl, 13–0.

Hinkle would talk about his thoughts on his final moments in the last college game of his career. Russell relayed Hinkle's recollections in one of his *Banner* columns:

> *I was groggy going off the field, a little sick at my stomach. The between-halves rest helped. No complaints from the coaches; just a few instructions. We went back out really "ready" and had that touchdown pretty quick. They couldn't stop Bert Marshall. When Joe Agee made the extra point, I was sure we had 'em. It was a great feeling.*
>
> *Then they started a terrific drive. We were tiring, but I thought we could hold on. When they got to out to fourteen, fourth down, and Sanford came in, I guessed wrong again, thinking it might be a fake. Rushed him all I could, though. A field goal through the middle, and we were behind again.*

But until the very last play I still thought we might get 'em, that Marshall might get loose. Then it was over.

I reached down and got the ball. I knew I couldn't keep it. They deserved it. I handed it to Kilgrow. As I walked to the field house, I realized my playing days were over. I had to laugh a bit. I wasn't ashamed to lose. It had to be someone—why not us? Amazingly, I felt all right. It wasn't painful. I didn't cry. I wished we were starting over.

Joe Kilgrow was Alabama's all-American halfback and finished fifth in the Heisman Trophy voting that season. Hinkle was seventh in the voting. The year 1937 was the third the award had been in existence. Running back Clint Frank of Yale was the 1937 recipient of the Heisman Trophy.

Carl Hinkle was voted the SEC's Most Valuable Player in 1937. *Courtesy of Vanderbilt Athletic Communications.*

Tales of Commodore Gridiron History

Hinkle won the 1937 SEC Most Valuable Player Award (just the sixth Vandy player to receive the honor) and a First Team all-American selection by the *Associated Press*, Grantland Rice and *Liberty*. He was enshrined in the National College Football Hall of Fame in 1959.

After graduation, Hinkle turned down several offers to coach and play professional football. Hinkle did accept an appointment to West Point, although he was ineligible to play football. However, Hinkle did scrimmage with the Cadets. At West Point, Hinkle received the top military honor by being named regimental commander (first captain). The honor also presented Hinkle with the General John Pershing Sword.

During World War II, Hinkle served as a pilot and won the Distinguished Flying Cross with two Oak Leaf Clusters, Presidential Citation Unit with Oak Leaf Clusters, France's Croix de Guerre and the Air Force Medal of Commendation. Hinkle retired from the air force as a colonel.

Hinkle was named to the Vanderbilt Hall of Fame in 1969 and the Tennessee Sports Hall of Fame in 1970. He died of a heart attack in 1992 at age seventy-five in Little Rock, Arkansas. Hinkle was buried with full military honors in the National Cemetery of Little Rock.

BILL WADE BECAME A QUARTERBACK LEGEND

Long before professional football came to Nashville, a few Nashvillians came to professional football. None was more celebrated than former Vanderbilt quarterback Bill Wade, who came up through the ranks at Nashville schools before going to Vanderbilt and finally to the NFL's Los Angeles Rams and Chicago Bears.

Wade was born on October 4, 1930, in Vanderbilt Hospital and was one of two sons of former 1921 Vanderbilt football captain William J. Wade Sr. Bill Wade began his athletic career at Woodmont Grammar School, where he played the guard position.

The most memorable experience at Woodmont was the first game he played at Vanderbilt's Dudley Field. His team played another grammar school as the halftime entertainment of a Vanderbilt football game. Wade prepped at Montgomery Bell Academy, receiving a scholarship to the seventh grade. Wade recalled:

> *MBA was the vital aspect of my total life. I walked to school almost every day. We played the forerunner to the Clinic Bowl. We had played Isaac Litton at the first of the year and beat them, and I think they went through the rest of the season undefeated. They more or less challenged us to play at Vanderbilt Stadium.*
>
> *So we played a game after the season was over against Isaac Litton. It was a super game. We had a large crowd, probably the largest high school crowd*

Tales of Commodore Gridiron History

in the history of Nashville up to that point in 1947. Three touchdowns were scored in twenty-two seconds on the clock. We scored and kicked off to them, and Kenneth Duke ran the ball all the way for a touchdown. They kicked off to us, and Billy Joe Earhardt ran it all the way back for a touchdown. That was the headlines in the newspaper the next day.

MBA lost the rematch to Litton, with Wade playing mostly at tailback. Occasionally he played quarterback, usually in special formations to confuse the defense. When MBA was winning in a rout on two occasions, Wade followed his coach's instructions by catching the ball on a punt and kicked it back to them.

During his high schools days, Wade would go over to Dudley Field to throw and kick the football for fun. The fifteen-year-old kid gained the attention of certain bystanders, tossing the ball fifty or sixty yards. The kid had been noticed. As a versatile athlete, Wade was also a pitcher on the MBA baseball team. Once he struck out twenty-one batters in a game against Hillsboro.

Vanderbilt's coach, Red Sanders, offered Wade a football scholarship, which he accepted without hesitation. Wade had been practically raised on the campus, witnessing numerous games with his father as a youngster. Freshmen were ineligible for the varsity, so Wade played on the freshman team.

Bill Wade was an all-American quarterback at Vanderbilt and the 1951 SEC Player of the Year. He had a fourteen-year NFL career with the Los Angeles Rams and Chicago Bears.
Courtesy of Vanderbilt Athletic Communications.

Wade, learning the quarterback position, led his team as a freshman to victories over Ole Miss and Kentucky, as well as narrowly losing to Tennessee. Wade gained recognition as a freshman and was featured in *Look* magazine's 1949 "Football Forecast" written by Grantland Rice.

Wade was on the cover with two Vanderbilt coeds. Rice ranked Vanderbilt third in the nation in a preseason poll. He wrote to watch out for sophomore Wade, an excellent passer and punter. Wade recalled:

> *They had put my picture on the cover of* Look *magazine before the 1949 season started. I didn't play a lot my sophomore season, Jamie Wade [no relation] played more than I did and did a very good job. Then Red Sanders left and went to UCLA. Our coach was gone, and Bill Edwards came down to be the coach.*
>
> *We opened up against Georgia Tech with a full house, and I will never forget it. This* Look *magazine came out right before our first game. There I was on the front of* Look *magazine with Dot and Peggy Neal, both of them were from Atlanta, though they were in Vanderbilt. The crowd kept yelling at me "Hey glamour boy."*

Wade's last game of his career was a tough loss against Tennessee, which would eventually become the national champion. The last collegiate pass he "completed" was to his younger brother, Don. Don Wade was a guard pulling on a screen pass to block when he went too far down the field. He instinctively caught the pass from his brother. The play was illegal and stopped Vandy's final drive of the game.

In Wade's three seasons at Vanderbilt, he never had a losing season. Wade's career total offense of 3,388 yards and career passing yardage (3,396) stood as the school record for more than thirty years and remains eighth on the all-time list. He also shares the school record for most touchdown passes in a game (five) with Jay Cutler and has the fourth-longest pass (85) in school history.

Concluding his collegiate career, Wade was named the SEC's Most Valuable Player and a Second Team all-American. He was also MVP of the 1951 North-South Shrine Bowl game in Miami. Wade also played in the Senior Bowl of 1952 and was selected to play in the College All-Star game in Chicago.

Wade's postseason performances caught the attention of NFL scouts. It has been widely acclaimed and published that Wade was the first-round pick of the Los Angeles Rams, but that is not correct, as Wade explained:

Tales of Commodore Gridiron History

In 1952, I was the Rams' "bonus draft" choice. There is no such thing as a bonus draft choice any more, but at the time the professional football teams would put their names in a hat, and they would draw for a bonus draft pick for each team before the actual draft. There is no bonus draft pick today.

I was told that Frank Gifford resented me, because I was the bonus pick of the Rams. Gifford was a graduate of Southern Cal, and he wanted to be the bonus pick of the Los Angeles Rams. He was the no. 1 draft choice of the New York Giants. I was the bonus pick of the Rams, and the no. 1 draft pick of the Rams was Les Richter of California, a linebacker.

The Rams did Gifford a favor, because Gifford went to New York, and he would never have had that broadcasting job that paid him tons of money, and he might never had met Kathie Lee [Wade laughing] *if Gifford never went to New York.*

After serving two years in the navy as an officer, Wade entered the Rams' training camp in 1954, competing with one hundred other determined rookies. For two years, Wade had to play in the shadow of Norm van Brocklin. In 1956, he earned the starting quarterback slot and was the second leading passer in the NFL. But the next season, a disappointed Wade found himself once again on the bench.

"Our coach in 1954 was Hampton Poole. I felt that I had won the job fairly and squarely," Wade said. "I did not get to play much, but every time I did, we played well. In 1955, I was put on the bench again by the new coach Sid Gillman."

"Van Brocklin had given them an ultimatum in 1957," Wade continued, "either play him the whole time, or if they didn't win the championship they could trade him. They traded him, and in 1958 I became the first-string quarterback. It was very difficult for me to sit on the bench and watch him play football."

In 1961, his request for a trade was granted, and he went to the Chicago Bears, where the highlight of his career was directing George Halas's legendary team to the 1963 NFL championship. The game was played at Chicago's Wrigley Field against Gifford's New York Giants.

Halas would let Wade call his own plays. Wade scored the Bears' only two touchdowns in a 14–10 victory:

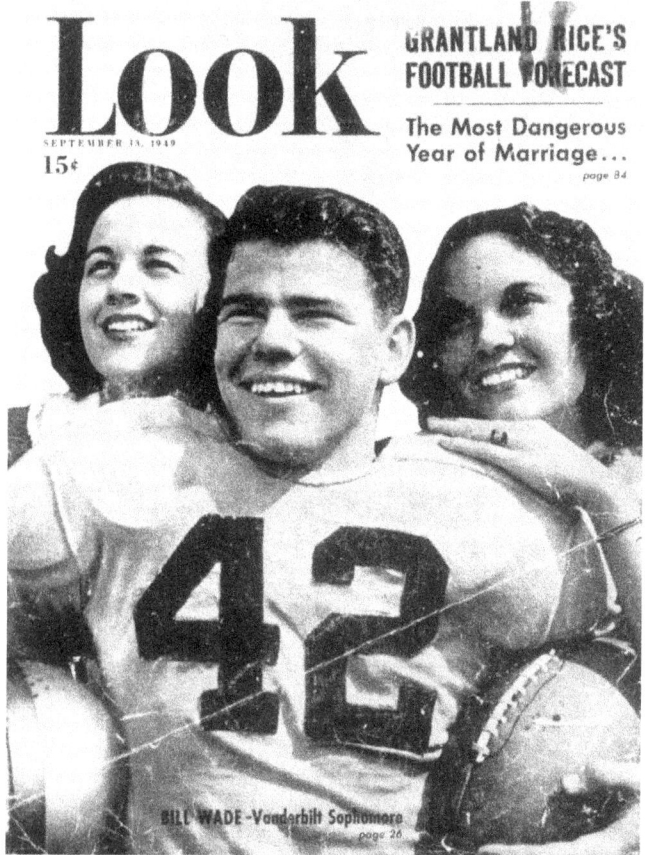

Bill Wade made this *Look* cover as a Vanderbilt sophomore. *Courtesy of the author.*

In the game, I was going to run the ball. I felt that I could run against the Giants. On the first time I ran the ball, I made a fake cut to my right and cut to back the left, and I did not know that a guy was chasing me, and he knocked the ball out of my hands. They recovered the ball and went on to score. We had to come back from a deficit, because in my mind it was my problem because I had fumbled the ball.

We had two interceptions that led to our touchdowns. I made the two scores in the game on quarterback sneaks. I did not want to hand off to anybody. I did not want to take a chance on a fumble. I would have run quarterback sneaks until we scored.

During Wade's final two seasons, he was hampered by injuries, which resulted in surgery on his knee. Serving one season in 1967 as an assistant

coach, Wade moved to Nashville and began a banking career with Third National Bank. He retired from the bank in 1990.

Wade, who had two sons and two daughters, faced tragedy in his life. His brother Don, after being cut from the Rams, was killed in a car accident in 1956. Wade's second son, also named Don, died in 1985. A divorce soon followed, and Wade remarried in 1991.

"I was away too much," said Wade, who has been a member of the Fellowship of Christian Athletes for more than forty years and has given testimonials across the country. "My message is bide your time like you do your talent. If I had been wise enough to see that my children were being hurt by my not being here enough, I would have never had gone to speak. I thought I was doing God's work, and I made a big mistake. Don't go more than 10 percent of your time or you're doing your family wrong."

Wade was named to the Tennessee Sports Hall of Fame in 1966 and was selected to the inaugural Vanderbilt Athletic Hall of Fame induction class in 2007.

Dudley Field's First Night Game

Vanderbilt played its first night football game at Dudley Field on September 25, 1954, against Baylor University. Evangelist Billy Graham, who had held his crusade at the stadium earlier that year, donated the permanent lights.

It was reported that the lighting for nighttime football at Dudley Field was some of the best in the country. However, photographers tested their cameras the night before during a Baylor workout. They were not pleased with the darkness of their photographs. Obviously the equipment and film in those days were behind what advanced technology has brought today.

Quite a bit of comparison was made to the Nashville Vols baseball club that had played its first night game at Sulphur Dell twenty-three years earlier. Night games came into existence hoping to draw a larger number of fans. During the past few years at this time, Vanderbilt's football attendance had been slipping due to poor records. The players also enjoyed the cooler temperatures at night.

Vanderbilt was playing in its season opener with Coach Art Guepe in his second year as the Commodores' coach. Baylor came into the game as a three-touchdown favorite and was coming off a walloping win over Houston, 53–13. The year before, Baylor beat Vanderbilt 47–6 in Waco.

It was also reported that twenty-five thousand screaming fans were in attendance as the tenth-ranked Bears narrowly defeated the Commodores, 25–19. Vanderbilt was trailing at the end of the first half, 19–12.

Tales of Commodore Gridiron History

Charley Horton was an all-American running back for the Commodores. In 1955, he established a then school record twelve touchdowns. *Courtesy of Vanderbilt Athletic Communications.*

The Commodores opened the scoring with their first possession of the game. The eighty-two-yard drive was capped by halfback Charley Horton's three-yard blast. Horton had eight carries during that initial drive for thirty-one yards. Quarterback Jim Looney completed his two passing attempts to continue the drive. A twenty-nine-yard pitch to end Joe Stephenson set up the Horton TD at the Baylor three-yard line. Vanderbilt took an early 7–0 lead.

After a Baylor fumble was recovered by Commodore defensive tackle Buck Watson, Vanderbilt would score more points on an eighteen-yard field goal by kicker Bobby Goodall. Vanderbilt now led 10–0.

Baylor came storming back. Baylor running back L.G. Dupre took the Vandy kickoff thirty-four yards to the Bears' forty-four-yard line. A few plays later, Dupre plowed through the Commodore line for a nine-yard touchdown. The point after touchdown kick was wide. Vanderbilt held on to a 10–6 lead.

Early in the second quarter, Commodore quarterback Don Orr threw an interception to Baylor's defensive back Delbert Shofner at the Baylor forty-six-yard line. Dupre later scored his second touchdown on a three-yard run.

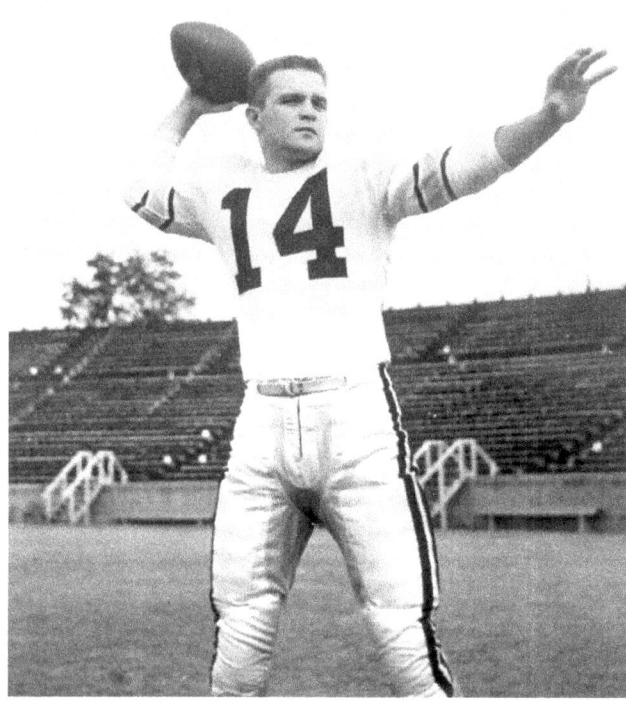

Jim Looney was a Vanderbilt quarterback in 1953–54. *Courtesy of Vanderbilt Athletic Communications.*

The conversion was good, and Baylor took the lead 13–10, with 6:13 left in the first half.

Vanderbilt was held on its next possession. The Commodore punt sailed into the end zone, but Dupre attempted to run the ball instead of downing it. He was slammed to the ground at the Baylor six-yard line. Two plays later, a Baylor pitchout was fumbled, and Dupre was tackled in the end zone.

Vanderbilt end Terry Fails and tackle Jason Papuchis were credited with the Commodore safety. Vanderbilt closed the gap to 13–12. The Commodores were in good shape as they received the free kick. However, a Baylor interception gave the Bears a first down on their own thirteen-yard line.

Two running plays later, Baylor had the ball on the thirty-four-yard line with fifteen seconds remaining. A miracle pass from Baylor quarterback Bobby Jones to end Henry Gremminger covered the remaining sixty-six yards as time ran out. The kick was missed, and Baylor went into the locker room with a 19–12 halftime lead.

Tales of Commodore Gridiron History

Midway in the third quarter, Papuchis recovered a Bear fumble at the Baylor twenty-seven-yard line. It would take eight plays for Vanderbilt to score a touchdown on the short drive. Horton bulled his way into the end zone from the two-yard line. The conversion was good and the game was tied at 19–19.

Vanderbilt's defense gave Baylor a heroic effort until just before the end of the game. Vanderbilt was forced to punt from its own end zone, where Dupre called for a fair catch at the Commodore forty-one-yard line. Keeping the ball on the ground, Baylor drove the ball to the twelve-yard line.

An offside penalty against the Commodores placed the ball on the seven-yard line. Three plays later, Jones smashed his way into the end zone for the winning touchdown with 1:37 to play. The conversion failed. Baylor led, 25–19.

The lights that were installed in 1954 at Dudley Field were donated by evangelist Billy Graham, who earlier that year had held a crusade in the stadium.
Courtesy of Vanderbilt Special Collections and Archives.

BAYLOR vs. VANDERBILT
Dudley Field, September 25, 1954
Official Program 35 Cents

Vanderbilt tried to score in desperation but was stopped; the game ended with Vanderbilt losing its first home night game.

Baylor rushed for 312 yards to Vanderbilt's 129. Dupre led the Bears with 92 yards in twenty carries. Shofner gained 88 yards in twelve attempts. Horton recorded 42 yards with twelve carries to lead Vanderbilt. Looney was seven of fourteen for 115 yards passing for the Commodores. The defensive leaders for Vanderbilt were Bobby Goodall, Watson and co-captain Pete Williams.

Vanderbilt played its first night football game on October 28, 1933, in Baton Rouge, Louisiana, against LSU.

THE 1955 GATOR BOWL

Vanderbilt coach Art Guepe was delighted that his Commodore football team was rewarded with a New Year's Eve Gator Bowl invitation in 1955. The Commodores finished the regular season with a surprising 8-3 record and were making their first bowl appearance in school history. A large task was evident with their fellow SEC member Auburn as the opponent. The Tigers were ranked eighth in the nation.

An estimated thirty-six thousand fans in Jacksonville, Florida, were on hand to see Vanderbilt's wounded quarterback play an outstanding game. Don Orr had dislocated his right elbow five weeks earlier in the loss against Tennessee.

"Orr hadn't hit a lick in practice," Guepe said after the game. "We didn't know for sure his elbow had recovered from the injury in the final season game against Tennessee. I was going to start Tommy Harkins at quarterback if we kicked off and said so to the team. Something like a tear came up in Orr's eye, so I said to him, 'Are you ready?' He said he was, so I said, 'Get in there.'"

Auburn was coached by Ralph "Shug" Jordan and had led the Tigers to an 8-1-1 regular season. The Sugar Bowl and the Cotton Bowl, to the school's dismay, shunned the Tigers. This was Auburn's third straight Gator Bowl appearance. There was a brief time that Vanderbilt considered rejecting the invitation.

Traveling home from the disappointing Tennessee loss, rumors were flying that the Gator Bowl probably would invite Vanderbilt. Upon the speculation,

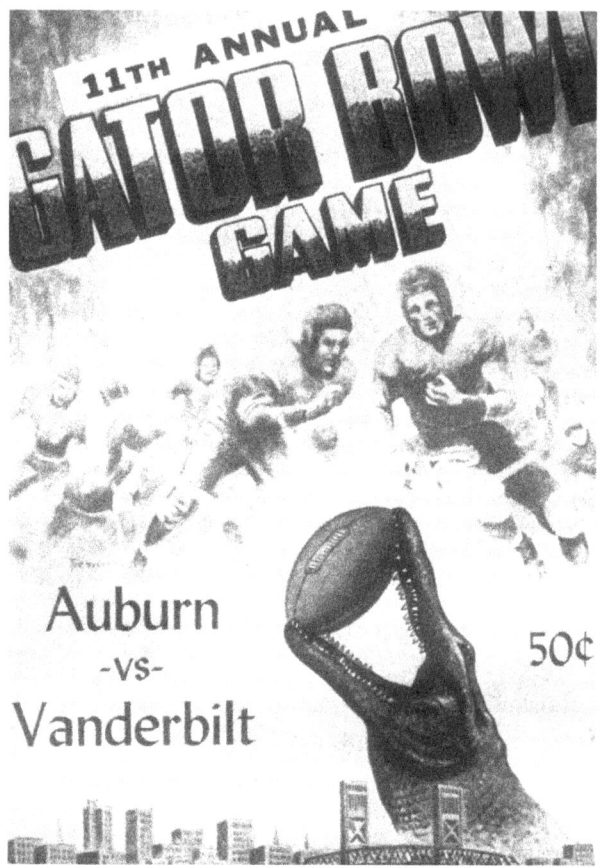

Vanderbilt played in its first bowl game against Auburn in the 1955 Gator Bowl. *Courtesy of Vanderbilt Athletic Communications.*

Guepe disagreed and said that they could not play anyway, because they didn't have a quarterback. The next morning, Guepe met with his trainers, Pinky Lipscomb and Joe Worden, about Orr's diagnosis. Guepe also met with the team, and all involved decided to accept the invitation.

Vanderbilt got on the scoreboard first late in the first quarter when Commodore tackle Tommy Woodroof jumped on an Auburn fumble. The Commodores had a first down on the Auburn thirty-nine-yard line. A key pass in the drive to receiver Joe Stephenson that covered fifteen yards put the ball on the Tigers' eight-yard line.

Phil King ran the ball to the two-yard line. On the next play, King bulled his way into the end zone, but a motion penalty nullified the play, and the ball was pushed back to the seven-yard line. Orr then confidently tossed a TD pass to Stephenson. Vanderbilt 7, Auburn 0.

Tales of Commodore Gridiron History

Vanderbilt head football coach Art Guepe (right) poses with the Gator Bowl championship trophy. *Courtesy of Vanderbilt Athletic Communications.*

The Tigers came back on their next possession on a ten-play march that resulted in a thirty-eight-yard pass from quarterback Howell Tubbs to Fob James, who scampered down the sideline for the tying touchdown. Vanderbilt 7, Auburn 7.

The Commodores struck quickly on their next possession. From their twenty-four-yard line, King ran for four yards; Orr then raced forty-four yards on a keeper to the Auburn twenty-eight-yard line. Joe Scales caught a twenty-four-yard pass from Orr and secured a first down at the Tiger four-yard line. Orr faked a handoff to King and rolled into the end zone standing up. The four-play drive gave the Commodores a 13–7 lead as the conversion failed. The lead held to the half.

In the second half, Tubbs's fourth fumble of the game gave Vanderbilt possession at its own forty-nine-yard line. Orr ran around end for sixteen yards but lost eleven yards on the next play when he was sacked. Scales caught a twenty-yard pass, Charlie Horton ran for fifteen and then five yards. Two plays later, Vanderbilt was facing a fourth down and a yard for the touchdown and two feet for a first down. King smashed into the line and just got the first down. Orr followed with a dive into the stubborn Tiger defense for his second touchdown of the day. The conversion was missed, and the Commodores led, 19–7.

In the third quarter, Vanderbilt got a big break when an Auburn punt only traveled twelve yards, and a roughing penalty gave the Commodores a starting point from the Tiger twenty-six-yard line. Horton ran for five yards, and Don Hunt dashed for an additional twenty yards. On the final play of the third period, Horton was held for no gain at the one.

More than five thousand Vanderbilt fans cheered as the teams changed ends of the field. The faithful Commodore followers were sitting in the end zone where their team was about to score. Horton blasted his way into the end zone, extending the Vanderbilt lead to 25–7, while the conversion kick was blocked.

Guepe cleared his bench in the final moments of the game. He used thirty-eight of his thirty-nine players. The Tigers finished the scoring with a seven-yard touchdown pass from Jimmy Cook to Joe Childress, capping a six-play drive covering sixty-six yards. The final score was in Vanderbilt's favor, 25–13. Auburn lost the ball to Vanderbilt on five fumbles.

Orr's big day included one touchdown pass and two rushing TDs. The sports writers unanimously named him the game's MVP. Each player from both teams received a commemorative watch for playing in the Eleventh Gator Bowl.

Guepe used a maneuver in the game that gave Vanderbilt an advantage on offense. He was in his third year at the Vanderbilt helm and had never used the ploy in a Commodore game before. Guepe used a double-flanker that opened the confused Auburn defense.

"This is truly one of my finest hours," Guepe said during the awards dinner after the game. "I can never repay these young men for what they have meant to me, Vanderbilt and its alumni and fans across the country. In adversity and victory, they have been the greatest. It was a thrill for all of us, players and coaches, to defeat such a fine team as Auburn. This is truly one of my finest hours."

When it was Jordan's time to speak, he asked for Orr to stand. Jordan congratulated him on his performance and joked that he was glad that he didn't dislocate both his elbows. "We lost to the finest team we've played all year," Jordan said. "It was a pleasure to play with such a fine team as Vanderbilt. You men are clean and fine in victory and true sportsmen."

Orr went on to become a longtime referee in the National Football League. His prominence and competence in the NFL earned him several Super Bowl and playoff experiences. He received a standing ovation when

Tales of Commodore Gridiron History

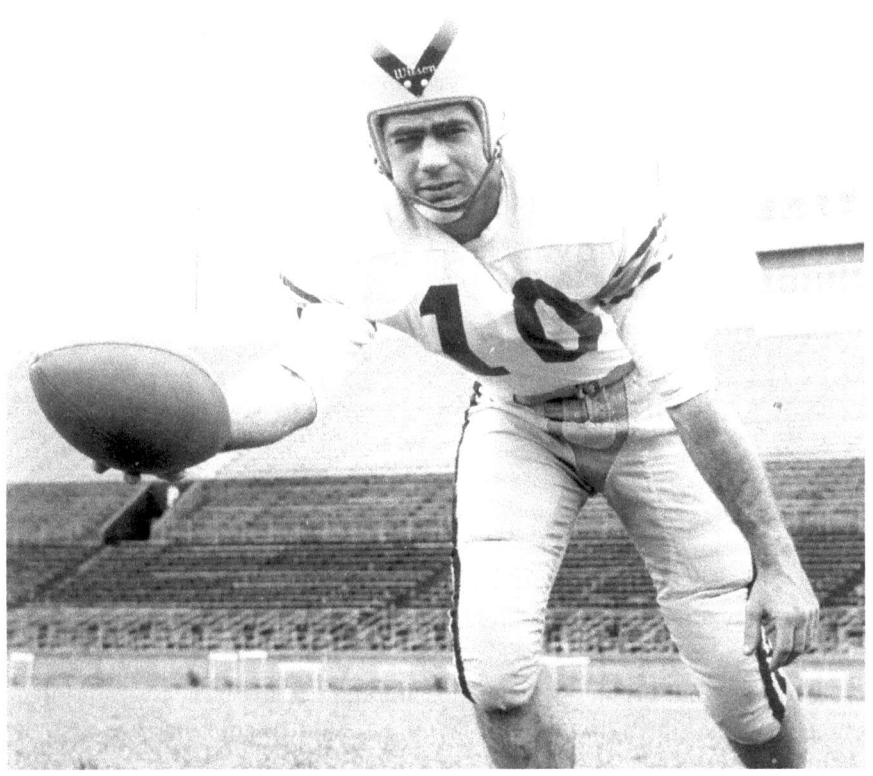

Quarterback Don Orr was four of six for sixty-seven passing yards, leading the Commodores to a 25–13 win over the Tigers in the Gator Bowl. He also passed for one touchdown and added two rushing TDs in earning the game's MVP honors. *Courtesy of Vanderbilt Athletic Communications.*

he went to the podium for his MVP trophy. He recalled: "No one player can win something like this. I want to thank the other thirty-eight men on our squad, my coaches and especially Dr. Pinky Lipscomb and Trainer Joe Worden, who got me ready and possible for me to play."

Vanderbilt Upsets Alabama in 1969

"VU 14–10! How Sweet It Is," noted the *Tennessean*'s sports headline the day after Vanderbilt upset Paul "Bear" Bryant's Crimson Tide at Dudley Field.

"This was what I remember the most about my two years at Vanderbilt," former Vanderbilt tailback Doug Mathews said about the October 11, 1969 game. "It was a total team win. Our defense played really well. Our offense played well and our kicking game was good. Everybody got the ball. There wasn't one guy making one big play; we had a lot of guys make big plays."

This gridiron match would be the last Commodore win against Alabama in Nashville. Head Coach Bill Pace was in the midst of a dismal 0-3 record entering the game.

Cookeville's Watson Brown, Vandy's sophomore quarterback, was in his first season of varsity football and was instrumental in the glorious victory. He was the starting quarterback but split time behind center with fellow sophomore Denny Painter. The Tide was injury-ridden, with star tailback Johnny Musso on the sideline unable to perform.

But Alabama's offensive leader was celebrated junior quarterback Scott Hunter. Hunter entered the game leading the nation in passing accuracy, completing an amazing 75.4 percent of his passes. The Crimson Tide was undefeated (3-0) and ranked thirteenth nationally. The betting line showed Vanderbilt as seventeen- to twenty-point underdogs.

Tales of Commodore Gridiron History

Watson Brown's playing career was limited due to injuries, and he later became the offensive coordinator and head football coach at Vanderbilt. The popular Brown was also a head coach at Austin Peay, Cincinnati, Rice, UAB and Tennessee Tech. *Courtesy of Vanderbilt Athletic Communications.*

In a 2007 interview, Brown said about the game:

> *Coach Bryant, before the game, walked by me and was cutting up with me. He said, "You couldn't throw when I recruited you and you can't throw now. And you will never be able to throw." He just kept walking and patted me on the head. Then after we won the game, he found me in the melee, and it was a melee. He gave me a hug and didn't say anything and strolled to the locker room.*

The packed stadium of more than thirty-four thousand loyal Vandy fans anxiously awaited the 7:30 p.m. kickoff on a cool evening with rain-threatening skies. The Commodores opened the game kicking off to Alabama, but an inspired Commodore defense forced the Tide to punt on the first series.

Vanderbilt Football

On the Bama punt, Commodore Neal Smith fielded the football at his sixteen-yard line and dodged one Tide defender after another, racing into the end zone for an apparent eighty-four-yard return. The unexpected feat brought the crowd to its feet.

However, on the return, a penalty was called on Mathews, who called for a fair catch on the play, and the touchdown was nullified. Mathews was a senior tailback from Northeast Oklahoma Junior College. The penalty would be the first of ten against Vandy, which significantly handicapped the offense.

Each team was unable to sustain a lengthy drive until just before the end of the first quarter, when an Alabama drive stalled at the Vanderbilt two. Mike Dean connected on a nineteen-yard field goal to give the Tide an early 3–0 lead.

On the ensuing kickoff, Commodore John Valput returned the ball forty-two yards to the midfield stripe, giving the 'Dores a first down in excellent field position. The highlight of the drive was a halfback pass from Mathews to wingback John Ingram for thirty-eight yards. That play set up another unexpected halfback pass by Mathews from six yards out, this time to wingback David Strong, who was standing all alone in the end zone.

"We were running a veer option offense at that time and later changed to the I-formation," Mathews said. "I had been a quarterback in junior college, and in high school for that matter. So we had the halfback pass put in and threw a good bit off it."

Jay Wollins, a walk-on, booted the extra point, capping the fifty-yard drive and erasing the Tide's early advantage. The defenses for each team stiffened, and the halftime score read Vanderbilt 7, Alabama 3.

Vanderbilt opened the second half with possession of the football. Mathews was hit hard and fumbled, and Alabama's defensive end, Wayne Rhodes, made the recovery at the Vanderbilt nineteen-yard line.

On the first play from scrimmage, George Ranger swept around the right end for a Tide touchdown. With just 1:35 elapsed in the third quarter, Dean's conversion gave Alabama a 10–7 margin.

In the third quarter, Vanderbilt, combining a short passing and running game, consumed nine minutes off the clock in a twenty-five-play drive. With the ball resting on the one-yard line, the Commodores failed to stick the ball into the end zone. Wollins was called on for a field goal attempt, but the ball sailed to the left of the uprights.

Tales of Commodore Gridiron History

The Commodore defense, led by Pat Toomay, put pressure on Hunter throughout the game, and the secondary, consisting of Mal Wall, Greg O'Neal and Christie Hauck, disrupted the passing game.

Early in the fourth quarter, Alabama drove deep into Commodore territory, with Hunter looking to put the game out of reach. But Hauck intercepted an erratic Hunter pass at the eight-yard line, killing the drive.

Vanderbilt began its march to the winning touchdown with 7:30 left in the game. Painter began the drive by hitting Curt Chesley on passes of eighteen, six and seventeen yards. A key pass to David Strong of nineteen yards extended the drive.

Brown, who turned down a scholarship from Bryant, came into the game with a first-down situation at the Tide's twenty-one-yard line. On Brown's first play, he handed off to Mathews, who bulled his way for eleven yards down to the ten. Daniel Lipperman failed to gain a yard on a running play, setting up a second-and-long situation.

Brown turned to his right, faked a handoff, suddenly turned and threw a strike to tight end Jim Cunningham. Cunningham, who had stayed on the line of scrimmage, caught the ball and sprinted into the end zone. Pandemonium broke out in the stands as the crowd reacted to the dramatic finish. Wollins's conversion was successful, and Vanderbilt took the lead, 14–10.

However, there were still two minutes on the clock, plenty of time for gunslinger Hunter to move the ball into scoring range. The stubborn Vandy defense forced Alabama into a fourth-down situation on its own twenty-one-yard line. Commodore defender Les Lyle broke through the line and slammed Hunter to the ground on the Tide's final desperation pass attempt.

The delirious Vanderbilt fans believed that the game over, but another penalty flag was thrown against the defense. Alabama still needed two yards for a first down, as the offside penalty did not give Bama the much-needed first down. On the next play, defensive tackle Buzz Hamilton exploded through the line, crushing Hunter and forcing him to throw an underhanded pass that landed harmlessly on the ground.

Vanderbilt held on to the football long enough to win the game, 14–10. Vanderbilt also won the statistics battle, gaining 473 total yards to Alabama's 201. Hunter was able to connect on only four of twenty-five passes for 91 yards. The passing duo of Brown and Painter completed twenty-two of thirty-four for 265 yards. Vanderbilt also controlled the line of scrimmage,

Doug Mathews is the only Vanderbilt running back to lead the SEC in rushing. His 849 yards in 1969 was tops in the conference. *Courtesy of Vanderbilt Athletic Communications.*

totaling twenty-eight first downs against just ten for Alabama. Brown led all rushers with 68 yards.

"Alabama football has reached to the bottom and Vanderbilt put us there," Bryant said on his television show the next morning. "They not only beat us,

but they embarrassed us. Vandy was highly motivated; they out-gained us, out-hit us, out-ran us, out-passed us and out-caught us."

"It probably helped football in the conference, but I can't see any way it helps football at Alabama. We've fallen hard. We're really going to have a gut test now and there's no doubt about it," he concluded.

Vanderbilt concluded the season with a 4-6 record, while Alabama closed out a disappointing 6-5 campaign with a loss to Colorado in the Liberty Bowl. Mathews led the Southeastern Conference in rushing that season with 849 yards, the only Commodore to ever lead the conference in rushing.

"It was a shot in the arm for the program when it really needed it, because nobody expected us to win," said Mathews. "Some games you win and maybe you shouldn't, but we outplayed them the whole ballgame and the score could have been worse than 14–10. We clearly outplayed them."

THE 1974 PEACH BOWL

It was not known at the time, but the 1974 Peach Bowl would be the last game for Steve Sloan to coach Vanderbilt. The 1974 Commodores entered the seventh annual Peach Bowl in Atlanta Stadium with a 7-3-1 record.

Only twenty-five thousand fans were in attendance, with the majority belonging to Vanderbilt. Their opponent was Texas Tech, coached by Jim Carlen. It was known that this would be Carlen's last game at Tech, as he had been named the new head coach at South Carolina.

The game ended in a 6–6 deadlock, with field goals accounting for all of the scoring. Both defenses would dominate the game. Defensive tackle Dennis Harrison was a Commodore freshman and dominated on defense to earn MVP honors. His blocked field goal attempt by the Raiders was a key factor in preventing a Commodore loss.

Vanderbilt never trailed in the game. Late in the first half, Vanderbilt quarterback David Lee overthrew a pass to Walter Overton that was intercepted in the Red Raider end zone. A few plays later, Jay Chesley picked off a Tech pass, returning the ball to the Raider fourteen-yard line. The short drive stalled, and Mark Adams booted a Vandy field goal good for thirty yards. The Commodores led, 3–0.

Just before the half ended, Tech intercepted another Vanderbilt pass and drove to the Commodore one-yard line. This was Tech's only scoring threat in the first half. With less than a minute until intermission, Tech running

Tales of Commodore Gridiron History

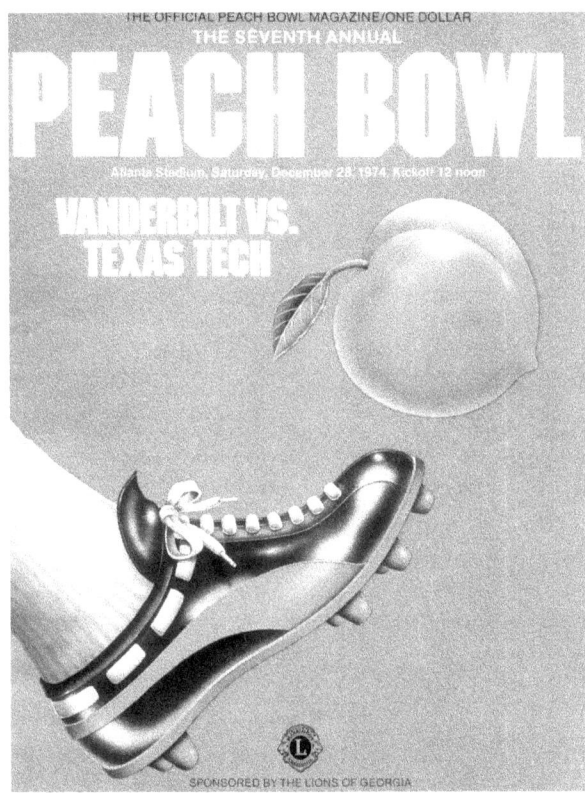

Vanderbilt would tie Texas Tech (0–0) in the 1974 Peach Bowl in Atlanta. *Courtesy of the author.*

back Larry Isaac was stopped for no gain. With one timeout and the clock down to fourteen seconds, Isaac was stymied again for no yards gained.

Only two seconds remained when the Raiders attempted another rush into the stubborn Vandy line. The results were the same, as Tech failed to advance the ball on third down and the clock expired. The twelve thousand Vanderbilt fans roared as the outstanding defensive stand occurred in their end zone.

In the third period, Tech drove the ball from its seven-yard line to the Commodore ten. Vanderbilt held, and Raider kicker Brian Hall tied the game at 3–3 with a twenty-six-yard field goal. Later, a Tech fumble gave Vanderbilt another scoring opportunity at the Raider eighteen-yard line. After three plays failed to make a first down, Adams kicked a twenty-six-yard field goal, producing a 6–3 Commodore lead with 5:11 left in the game.

Laurence Williams took the Vanderbilt kickoff fifty-four yards (a then Peach Bowl record) to set up Tech's final field goal. The Raiders eventually kicked a thirty-five-yard field at the 2:27 mark to finalize the score at 6–6.

Quarterback David Lee played three seasons for Vanderbilt (1972–74) and led the Commodores in passing with 1,450 yards and eleven touchdowns in 1974. *Courtesy of Vanderbilt Athletic Communications.*

Several Peach Bowl records were recorded that day in the "fewest" category. They included times penalized (one each); points scored, both teams (twelve); passes completed, both teams (eight—Tech three, Vandy five); yards passing both teams, (95—Tech 35, Vandy 60); yards total offense, both teams (541—Tech 341, Vandy 200); and first downs, one team (Vandy, ten).

After the game, Carlen was asked about not throwing the ball away on third down during the crucial late first half scoring chance at the Vandy one:

> *I called two plays from the sidelines, and if we didn't get it in then, I told him* [quarterback Tommy Duniven] *to kill the clock so that we could set up for a field goal. The boy felt that we could get it in on the third-down play. But I must give credit where credit is due; Vandy made three fine plays. I accept responsibility for those calls.*

Tales of Commodore Gridiron History

Failing to score before the half hurt, and we also got a field goal blocked. That's never happened since I've been at Tech. If I had known how big and mean No. 77 [Dennis Harrison] is, I'm not sure I would have tried that field goal.

Vanderbilt was led in rushing by Jamie O'Rouke with 76 yards. Isaac and Cliff Hoskins led the Raiders' rushers with 101 and 116 yards, respectively. Because of the deadlocked game, Peach Bowl officials announced that duplicate champions trophies would be awarded. Sloan recalled:

We get a trophy which we will put in McGugin Center that will serve to remember this bowl team. But we don't need the trophy to remember this team. Vanderbilt fans everywhere will recall this year and this football team. And they will be as proud as I am.

Jay Chesley intercepted five passes in 1974, returning two for touchdowns. He is the only Commodore to return two interceptions for touchdowns in the same year.
Courtesy of Vanderbilt Athletic Communications.

Vanderbilt Football

I just want everyone to know that being associated with this Vanderbilt football team—you guys have worked so hard—has given me my biggest thrill as a player or as a coach. I'm thrilled to be a part of this team. Man, I just want you to know that I appreciate it.

Vanderbilt finished the season at 7-3-2 and participated in only the university's second bowl game (1955 Gator Bowl). Sloan, only thirty years old, shocked the Vanderbilt community by announcing weeks later that he was leaving the Commodore program for the now vacated coaching position at Texas Tech. Sloan was Carlen's replacement. He was also named the SEC Coach of the Year.

In his just two years at Vanderbilt, Sloan compiled a 12-9-3 record but remains one of the most popular coaches with the Commodore followers. The former all-American quarterback at Alabama spent three years at Texas Tech. Sloan guided the Red Raiders to two bowl games and the 1976 co-championship of the Southwest Conference. Sloan later coached at Ole Miss (1978–82) and Duke (1983–86). He became athletic director at Alabama but returned to Vanderbilt as offensive coordinator (1990) under Watson Brown. He later became athletic director at Central Florida and presently is the athletic director at UT-Chattanooga.

I wonder what happened to all of those black-and-gold buttons that read, "We Believe in Steve."

WHIT TAYLOR'S TOUCHDOWN DEFEATS UT IN 1982

In a poll conducted by Vanderbilt University several years ago, the 1982 Tennessee match was named as one of the greatest football games. This is what happened on that rainy November 27 afternoon.

At that time, the game at Dudley Field was said to be the largest crowd (41,683) ever to witness a football game in Nashville. UT coach Johnny Majors brought his Vols into Nashville with a 6-3-1 record. Vanderbilt's George MacIntyre was 7-3 and already bowl-bound for the Hall of Fame game in Birmingham.

Vanderbilt was wearing all-gold uniforms with their black helmets, while UT was attired in all white. Vanderbilt's offensive coordinator, Watson Brown, would display strategy against Tennessee's defensive coordinator, Doug Mathews, a former Vanderbilt running back.

The Volunteers scored first with their third possession on an eighty-four-yard first period drive. Tailback Chuck Coleman finished the eleven-play drive with a three-yard blast into the end zone. UT quarterback Alan Cockrell engineered the drive as Fuad Reveiz added the conversion. There was 1:48 on the clock.

Vanderbilt struck back quickly with quarterback Whit Taylor directing a sixty-five-yard drive in just four plays. A twenty-four-yard pass reception to receiver Phil Roach set up a forty-two-yard touchdown strike to Arnez Perry. Ricky Anderson's conversion tied the game at 7–7. Only fifteen seconds remained in the first quarter.

Vanderbilt Football

All-SEC quarterback Whit Taylor sprints into the end zone for the winning touchdown against Tennessee (28–21) on Dudley Field in 1982. Taylor led the Commodores in passing for three seasons (1980–82). *Courtesy of Vanderbilt Athletic Communications.*

UT's John McClennon returned Anderson's ensuing kickoff to the twenty-four-yard line. On the return, Vanderbilt was penalized for a late hit, and the ball was placed on Tennessee's thirty-nine-yard line. The Volunteers were stopped with three consecutive running plays by Coleman. Jimmy Colquitt punted the ball but was hit by Vanderbilt's Leonard Coleman on the play.

The fifteen-yard penalty gave the Volunteers a first down at the Vanderbilt forty-one-yard line. Johnny Jones ran twice to the Vandy sixteen-yard line, followed by a fifteen-yard pass to Clyde Duncan. Jones plunged the final yard over the Vanderbilt defense for the touchdown. With Reveiz's conversion, UT led 14–7 with 12:00 remaining until the first half.

Vanderbilt failed to pick up a first down from its nineteen-yard line thanks to a Reggie White sack on Taylor. Vanderbilt punter Jim Arnold was standing in his end zone for the punt. Willie Gault returned the punt to the Vanderbilt forty-seven-yard line. A third-down sack on Cockrell by Vanderbilt lineman Willie Twyford forced the Volunteers to punt.

Tales of Commodore Gridiron History

By this time in the game, a steady rain was soaking the players. The entire game was played under those conditions. With 8:18 remaining in the half, Vanderbilt had the ball at its own seventeen-yard line. A holding penalty stalled the Vanderbilt drive, and Arnold was forced to punt.

The Volunteers had the ball on the UT forty-two-yard line. A holding penalty moved the ball back to the thirty-two-yard line. The Vols made one first down before punting the ball. A Colquitt forty-seven-yard punt into the end zone gave Vanderbilt the ball at the twenty-yard line. Less than three minutes remained in the half.

Keith Edwards caught a Taylor pass for eleven yards and then rushed the ball for two more yards. Chuck Scott hauled in a pass for eighteen yards, placing the ball on the midfield line. Taylor ran for eight yards, and then Norman Jordan turned the corner for eight running yards. A pass interference call by UT defender Lee Jenkins on Allama Matthews gave Vanderbilt a first down on the six-yard line.

Jordan ran for two yards but on the next play was stopped for a two-yard loss. Taylor found Scott in the end zone for the six-yard touchdown. With twenty seconds remaining in the half, Anderson knotted the game at 14–14.

On the ensuing kickoff, Anderson attempted a squib kick to avoid the dangerous Gault. The Vols pounced on the ball at the UT forty-eight-yard line. Cockrell tossed a sideline pass to tight end Kenny Jones for a nine-yard gain.

With three seconds on the clock, Reveiz was brought in to attempt a sixty-yard field goal. Reveiz came into the game kicking a remarkable twenty-seven of thirty field goals. His distant field goal attempt fell short, and the half ended. Vanderbilt 14, Tennessee 14.

Vanderbilt took possession of the ball on the twenty-five-yard line to start the third quarter. Taylor threw a pass to Roach for fourteen yards, and a shuffle pass to Edwards added six more yards. Taylor ran an option keeper for ten yards to the UT forty-five-yard line. An incomplete pass led to a Matthews tight end around run for three yards.

With the ball resting on the Volunteer forty-two-yard line, Taylor looked to pass on third down. Scott ran a post pattern and took in the Taylor pass for a forty-two-yard touchdown. With 13:24 on the clock, Anderson added the conversion for a 21–14 Commodore lead.

Another Anderson squib kick gave the Vols a first down at their thirty-six-yard line. Cockrell was unable to sustain a drive after three plays. Colquitt's fifty-five-yard punt sailed through the end zone.

Edwards began the drive with a ten-yard run and a first down. Edwards was stopped for no gain, and then a Taylor pass was incomplete. On third down, Taylor found Perry in the middle of the field for a twenty-six-yard gain. With the ball on the Tennessee forty-four-yard line, Taylor fumbled on an option. The Vols took over at their own forty-two-yard line.

On the Vols' first play of the drive, Vanderbilt defensive back Coleman intercepted a Cockrell pass. The pick was Coleman's eighth of the season. Vanderbilt had the ball at its own forty-five-yard line.

Taylor hit Roach for nineteen yards to the Tennessee thirty-six-yard line. Vanderbilt was called for a holding penalty that pushed the ball back to the forty-two-yard line. An incomplete pass followed, and then Rich Holt sacked Taylor.

On a third-and-twenty situation, Taylor found Roach open in the Tennessee secondary for twenty-two yards and a first down. Matthews then caught a ten-yard pass for Vanderbilt at the UT twelve-yard line. On the next play, UT's Carlton Peoples killed the drive with an interception at the eleven-yard line. The Tennessee drive stalled after three plays, and Colquitt came on to punt the ball to the Vanderbilt forty-seven-yard line.

Vanderbilt tried a trick play with a pass to Edwards, who attempted a lateral to Jordan. The officials said that the lateral was forward, and a penalty with a loss of down was called. A shuffle pass to Scott gained twenty-four yards and a first down at the Vols' twenty-seven-yard line.

Edwards ran three straight times for gains of five, two and no yards. With the ball on the twenty-six-yard line, Anderson was called on for a field goal attempt. His thirty-four-yard attempt hooked to the left side of the goal post.

Cockrell was able to move the football from the twenty-yard line. Passes to Gault and Jones moved the ball to the UT forty-two-yard line. The running of Coleman and scrambling of Cockrell put the ball in Vanderbilt territory at the forty-two-yard line. Jones broke through the Vanderbilt defense for a forty-two-yard touchdown run. The score was 21–21 with 14:51 remaining in the game.

Both teams exchanged punts in their next possessions, while one Vanderbilt drive was killed by a Bill Bates interception. With 5:13 remaining in the game, Vanderbilt had possession on its fifteen-yard line.

Taylor ran the option for seven yards, and Edwards followed with five yards and a first down. Taylor dropped back to pass and hit a streaking Roach down the middle of the field. His sixty-five-yard romp took the ball

Tales of Commodore Gridiron History

Running back Keith Edwards led Vanderbilt in rushing in 1982 with 340 yards and three touchdowns. Edwards caught a team-record ninety-seven passes in 1983. *Courtesy of Vanderbilt Athletic Communications.*

to the Volunteers' eight-yard line. Taylor ran an option to the one-yard line. On the next play, Taylor faked a power dive to Edwards, sprinted to his right and rolled into the end zone untouched. Anderson added the conversion for the 28–21 Commodore lead. Only 2:53 remained in the game.

On the ensuing kickoff, another squib kick landed on the UT thirty-four-yard line. Gault caught a pass for just two yards, and then after an incomplete pass; Gault gained a first down with an eleven-yard catch. Doug Furnas caught a pass out of the backfield to the Vandy forty-yard line, but an illegal procedure call against the Vols pushed the ball back to the UT forty-one-yard line.

Cockrell completed passes to Darryal Wilson and Furnas for nine and eight yards. The ball was now on the Vanderbilt forty-two-yard line. Furnas caught a pass to the twenty-nine-yard line with twenty-seven seconds left. Cockrell scrambled for no gain, but a holding penalty on the Vols pushed the ball back to the thirty-nine-yard line.

Gault caught a ten-yard pass, and a timeout was called with ten seconds left. Vanderbilt's Glenn Watson then sacked Cockrell, and another timeout

was called, with the ball resting on the thirty-six-yard line. Only four seconds remained. Cockrell threw the ball toward Gault but was batted down by Commodore Mark Brown to end the game.

That was the first win for Vanderbilt over Tennessee since 1975. After the final play, Vanderbilt fans rushed onto the field and attempted to tear down the north end goal post. Security personnel surrounded the goal post to discourage the fans. So the fans just turned around and raced toward the south goal post. There they were successful.

Tennessee rushed for 187 yards, with Coleman (106) and Jones (90) the leading rushers. The leading rushers for Vanderbilt were Taylor with 42 yards and Edwards with 33 yards. Cockrell was eighteen of twenty-eight for 160 yards, while Taylor was twenty-four of forty-two for 391 yards. Gault and Jones led the Vols in receiving with five catches each for 33 yards. Roach led the Commodores in receiving with five catches for 144 yards, while Scott hauled in six passes for 118 yards.

Vanderbilt concluded its season at 8-4 with a Hall of Fame Bowl loss to Air Force, 36–28. Tennessee lost to Iowa in the Peach Bowl, 28–22, to finish at 6-5-1.

THE 1982 HALL OF FAME BOWL

The 1982 Vanderbilt football squad won its last five games to earn a bid to the Hall of Fame Bowl in Birmingham. Coach George MacIntyre led the Commodores to the school's third bowl game in its history with an 8-3 record. The opponent was the Falcons from the Air Force Academy.

This offensive display would see forty-one Hall of Fame Bowl records either tied or broken. Legion Field was the site as more than seventy thousand fans filled the stadium. Senior quarterback Whit Taylor led Vanderbilt's potent passing attack, while Air Force relied on a controlled wishbone formation.

Air Force piled up nineteen fourth-quarter points to outlast the Commodores' defense for a 36–28 win. Vanderbilt scored first in the opening quarter, covering seventy-five yards in seven plays. Norman Jordan slipped out of the backfield for a twenty-eight-yard touchdown reception. Vanderbilt led, 7–0.

The Falcons tied the game at 7–7 on a short thirty-seven-yard drive following a Keith Edwards fumble. Air Force quarterback Marty Louthan ran a sneak from the one-yard line for the score. After Vanderbilt failed on its next drive, the Falcons came back with an eighty-yard march to lead, 14–7. Mike Brown's nineteen-yard touchdown run capped the drive.

Vanderbilt struck back quickly with a pair of touchdowns. Taylor hit Phil Roach for a fifteen-yard TD to finish a sixty-three-yard drive in just five plays. Before the half, Vanderbilt had covered fifty yards in five plays, with Jordan taking another Taylor pass into the end zone. Vanderbilt led at the half, 21–14.

Vanderbilt Football

The Commodores were looking good at the end of the third quarter. Air Force managed a twenty-one-yard Sean Pavlich field goal, while the Commodores got another Taylor-to-Jordan touchdown pass from the four-yard line in the third period. Ricky Anderson kicked his third of four conversion attempts. Entering the final period, Vanderbilt was leading the Falcons, 28–17.

The Air Force rally began with a ninety-two-yard drive early in the fourth quarter. Ted Sundquist capped the drive with a three-yard plunge into the end zone. The conversion failed. Vanderbilt still led, 28–23.

The Commodores' offense was ridden with fourth-quarter mistakes. Taylor gave the Falcons a first down at the Commodore twenty-one-yard line when Falcon end Carl Dieudonne intercepted a pass. Taylor would be intercepted three times on the day, with two passes being picked off in the end zone.

John Kershner would score the go ahead touchdown with a three-yard run. The two-point attempt failed on the conversion, but the Falcons led 29–28. Later in the fourth quarter, an Air Force gamble shook the Commodores. The Falcons had the ball on the Vanderbilt forty-six-yard line with a fourth-and-one. Vanderbilt clogged the line, but Louthan ran the option play and scampered for a forty-six-yard touchdown. The conversion kick was good, and Air Force led, 36–28. A final desperation comeback by the Commodores came up short.

Taylor was named the game's MVP. He connected on thirty-eight of fifty-one passes for 452 yards and four touchdowns. Jordan caught twenty of those passes for 173 yards and three touchdowns. Vanderbilt collected 495 total yards, while Air Force totaled 451 yards. The Commodores only attempted twelve rushes for 35 yards. The Falcons gained 331 rushing yards.

"He is one of the most exciting quarterbacks the SEC has ever had," MacIntyre said about Taylor after the game. "Our timing was a little off considering the time we have had between games. I'm sure there are some passes Whit would have liked to have back. We simply couldn't stop their wishbone. Louthan did a great job of reading our defense. We didn't play well with our kicking game, either."

Another disappointment to Vanderbilt was the departure of offensive coordinator Watson Brown. Brown had earlier accepted the head coaching position at Cincinnati. He is credited for developing Taylor into the all–Southeastern Conference quarterback. Of course, Brown would go on to coach at other universities, including Rice University, and he later replaced MacIntyre (1986–90).

Tales of Commodore Gridiron History

Whit Taylor (10) was named the Hall of Fame Bowl MVP after completing a team-record thirty-eight passes in fifty-one attempts for 452 yards, which remains the second-highest single game passing total in Vanderbilt history. *Courtesy of the author.*

It was an emotional day for Brown, the former Vandy quarterback, in the postgame locker room:

> *It has been the toughest day of my life. I came out to the stadium, knowing it was my last with these guys, knowing I was going to have a tough time saying goodbye. I was determined to keep my composure, but I didn't. I lost my composure. I lost my poise. I cried.*
>
> *It hurt. Walking off the field, it was all I could think about, Whit, and these other kids. But, I can deal with it now, because I feel they are winners no matter the outcome of this game. Looking back on this season, no one could think differently.*

Jordan's twenty receptions is still a Vanderbilt single-game record. He broke five Hall of Fame records himself. Air Force nearly doubled the time of possession with 39:18, while Vandy controlled 20:42. Junior safety Manual Young collected sixteen tackles (ten unassisted), while linebackers Jeff McFerran and Bob O'Conner totaled fourteen tackles. Taylor recalled:

The loss hurts. Because I get the credit for winning, and I have learned to accept the blame when we lose. The interception in the end zone, and the one in the fourth quarter leading to their winning touchdown, were just mistakes. I wish I could get them back.

The last interception came on a special play designed for Air Force and not previously called. The receiver [Phil Roach] was clear. I just threw the ball short. It was very hard for me to accept the trophy [MVP]. Right now I'm just trying to get over the hurt. We should have won. That's what we wanted.

Originally, the Hall of Fame selection committee wanted Stanford as a foe for Vanderbilt. Stanford, with Heisman Trophy candidate quarterback John Elway, would have been a great passing match with Taylor. Stanford had the bid if it beat underdog California in its last regular season game.

Norman Jordan (34), coming out of the backfield, caught twenty passes for 173 yards and three touchdowns, breaking five Hall of Fame Bowl records. *Courtesy of Vanderbilt Athletic Communications.*

Tales of Commodore Gridiron History

That was the infamous Cal/Stanford band game. With Stanford winning the game and the victory locked up, a routine Cardinal kickoff would have ended the game. But the Stanford band prematurely ran onto the field during the final play, causing confusion and a Bears' touchdown. Cal won on the bizarre play, and Air Force was then asked to replace Stanford.

APPENDIX
ALL-TIME RECORDS

Year	W	L	T	Head Coach
1890	1	0	0	Elliott H. Jones
1891	3	1	0	Elliott H. Jones
1892	4	4	0	Elliott H. Jones
1893	6	1	0	W.J. Keller
1894	7	1	0	Henry Thornton
1895	5	3	1	C.L. Upton
1896	3	2	2	R.G. Acton
1897	6	0	1	R.G. Acton
1898	1	5	0	R.G. Acton
1899	7	2	0	J.L. Crane
1900	4	4	0	J.L. Crane
1901	6	1	1	W.H. Watkins
1902	8	1	0	W.H. Watkins
1903	6	1	1	J.H. Henry
1904	9	0	0	Dan McGugin
1905	7	1	0	Dan McGugin
1906	8	1	0	Dan McGugin

Appendix

Year	W	L	T	Head Coach
1907	5	1	1	Dan McGugin
1908	7	2	1	Dan McGugin
1909	7	3	0	Dan McGugin
1910	8	0	1	Dan McGugin
1911	8	1	0	Dan McGugin
1912	8	1	1	Dan McGugin
1913	5	3	0	Dan McGugin
1914	2	6	0	Dan McGugin
1915	9	1	0	Dan McGugin
1916	7	1	1	Dan McGugin
1917	5	3	0	Dan McGugin
1918	4	2	0	Ray Morrison
1919	5	1	2	Dan McGugin
1920	5	3	1	Dan McGugin
1921	7	0	1	Dan McGugin
1922	8	0	1	Dan McGugin
1923	5	2	1	Dan McGugin
1924	6	3	1	Dan McGugin
1925	6	3	0	Dan McGugin
1926	8	1	0	Dan McGugin
1927	8	1	2	Dan McGugin
1928	8	2	0	Dan McGugin
1929	7	2	0	Dan McGugin
1930	8	2	0	Dan McGugin
1931	5	4	0	Dan McGugin
1932	6	1	2	Dan McGugin
1933	4	3	3	Dan McGugin
1934	6	3	0	Dan McGugin
1935	7	3	0	Ray Morrison

Appendix

Year	W	L	T	Head Coach
1936	3	5	1	Ray Morrison
1937	7	2	0	Ray Morrison
1938	6	3	0	Ray Morrison
1939	2	7	1	Ray Morrison
1940	3	6	1	Red Sanders
1941	8	2	0	Red Sanders
1942	6	4	0	Red Sanders
1943	5	0	0	E.H. Alley
1944	3	0	1	Doby Bartling
1945	3	6	0	Doby Bartling
1946	5	4	0	Red Sanders
1947	6	4	0	Red Sanders
1948	8	2	1	Red Sanders
1949	5	5	0	Bill Edwards
1950	7	4	0	Bill Edwards
1951	6	5	0	Bill Edwards
1952	3	5	2	Bill Edwards
1953	3	7	0	Art Guepe
1954	2	7	0	Art Guepe
1955	8	3	0	Art Guepe
1956	5	5	0	Art Guepe
1957	5	3	2	Art Guepe
1958	5	2	3	Art Guepe
1959	5	3	2	Art Guepe
1960	3	7	0	Art Guepe
1961	2	8	0	Art Guepe
1962	1	9	0	Art Guepe
1963	1	7	2	Jack Green
1964	3	6	1	Jack Green

Appendix

Year	W	L	T	Head Coach
1965	2	7	1	Jack Green
1966	1	9	0	Jack Green
1967	2	7	1	Bill Pace
1968	5	4	1	Bill Pace
1969	4	6	0	Bill Pace
1970	4	7	0	Bill Pace
1971	4	6	1	Bill Pace
1972	3	8	0	Bill Pace
1973	5	6	0	Steve Sloan
1974	7	3	2	Steve Sloan
1975	7	4	0	Fred Pancoast
1976	2	9	0	Fred Pancoast
1977	2	9	0	Fred Pancoast
1978	2	9	0	Fred Pancoast
1979	1	10	0	George MacIntyre
1980	2	9	0	George MacIntyre
1981	4	7	0	George MacIntyre
1982	8	4	0	George MacIntyre
1983	2	9	0	George MacIntyre
1984	5	6	0	George MacIntyre
1985	3	7	1	George MacIntyre
1986	1	10	0	Watson Brown
1987	4	7	0	Watson Brown
1988	3	8	0	Watson Brown
1989	1	10	0	Watson Brown
1990	1	10	0	Watson Brown
1991	5	6	0	Gerry DiNardo
1992	4	7	0	Gerry DiNardo
1993	5	6	0	Gerry DiNardo

Appendix

Year	W	L	T	Head Coach
1994	5	6	0	Gerry DiNardo
1995	2	9	0	Rod Dowhower
1996	2	9	0	Rod Dowhower
1997	3	8	0	Woody Widenhofer
1998	2	9	0	Woody Widenhofer
1999	5	6	0	Woody Widenhofer
2000	3	8	0	Woody Widenhofer
2001	2	9	0	Woody Widenhofer
2002	2	10	0	Bobby Johnson
2003	2	10	0	Bobby Johnson
2004	2	9	0	Bobby Johnson
2005	5	6	0	Bobby Johnson
2006	4	8	0	Bobby Johnson
2007	5	7	0	Bobby Johnson
2008	7	6	0	Bobby Johnson
2009	2	10	0	Bobby Johnson
2010	2	10	0	Robbie Caldwell

Vanderbilt All-Time Record: 557-568-50

ABOUT THE AUTHOR

Bill Traughber has been a researcher and writer of Nashville sports history for fourteen years. The Nashville-born writer's work has appeared in *Athlon's Baseball Annual*, *Nashville Sports Weekly*, *Titans Exclusive*, *Big Orange Illustrated*, the *City Paper*, *Tennessee Titans Season Review* (2001–2), *Sports Nashville*, *Tennessee Sports Magazine* and the *National Pastime* (SABR).

The History Press published his first book, *Nashville Sports History: Stories From the Stands*, in March 2010. Traughber's second book, *Brentwood Academy Football: From a Cow Pasture to a Tradition, 1970–2009*, was published in September 2010 by McQuiddy Classic Printing in Nashville, Tennessee.

Traughber's stories have also appeared in these additional publications: *Nashville Sounds* 2004–11 yearly programs; *Nashville Sounds* 2007–11 media guides; Brentwood Academy 2004–10 football programs; Vanderbilt University 2004–10 football game programs; and Vanderbilt 2008–10 baseball media guides. His work has appeared on several websites, including nashvillesounds.com and vucommodores.com.

He has been recognized as a five-time winner in the Best Feature Writer category and a one-time Writer of the Year as a member of the Tennessee Sports Writers Association. Traughber has won several other writing awards from that organization, including these in Division III as a contributor to vucommodores.com (Commodore History Corner): 2011 Writer of the Year; 2010 Second-Place Writer of the Year; 2009 Best Feature Writer; 2008 Second-Place Feature Writer and 2007 Third-Place Feature Writer.

About the Author

Traughber has been a guest speaker for the Nashville Sports Council, Nashville Metro Archives, Fifth Annual Southern Association Baseball Conference, Nashville Downtown Lion's Club, Brentwood Rotary Club, Tennessee Historical Society and the David Lipscomb Golden Bison Club.

His memberships include the Tennessee Sports Writers Association (TSWA), Nashville Sports Council, Society of American Baseball Researchers (SABR), United States Basketball Writers Association (USBWA), Football Writers Association of America (FWAA) and the Intercollegiate Football Researchers Association (IFRA).

Traughber's stories have taken him to Cooperstown, New York; Anchorage, Alaska, and the White House in Washington, D.C. He resides in Brentwood, Tennessee.

www.ingramcontent.com/pod-product-compliance
Lightning Source LLC
Chambersburg PA
CBHW071410160426
42813CB00085B/950